PORTRAIT OF THE ARTIST

DAVID FRASER JENKINS & SARAH FOX-PITT

Portrait of the Artist

Artists' Portraits published by 'Art News & Review' 1949–1960

THE TATE GALLERY

cover/jacket
William Scott *Self-Portrait* 1950

ISBN 1 85437 007 3 (paper)
ISBN 1 85437 010 3 (hardback)
Copyright © 1989 The Tate Gallery All rights reserved
Designed and published by Tate Gallery Publications,
Millbank, London SW1P 4RG
Published by order of the Trustees 1989 for the exhibition
31 January–16 April 1989
Printed by BAS Printers Limited, Over Wallop, Hampshire

A TATE GALLERY ARCHIVE COLLECTION

Contents

Foreword

In 1982 the *Archive of 20th Century British Art* at the Tate Gallery acquired 122 artists' portraits from John Gainsborough. He had inherited this collection from his father Richard Gainsborough, the founder of the magazine *Art News & Review*. This journal ran under Gainsborough's patronage from 1949 until his death in 1969, changing its name to *The Arts Review* in 1961. It continues in a different format as a thriving concern.

Gainsborough's first editor, Bernard Denvir, conceived the idea of inviting living artists to create self-portraits for the front page of the magazine with an accompanying article often on the occasion of an exhibition. The collection published in this book is rather more than one third of the total number of contemporary portraits published by *Art News & Review*.

Between February 1949 and January 1959 some 227 artists' portraits were published, including old masters and modern artists. As a result many portraits were reproduced from existing works. In order to show some portraits that have not entered the Tate Gallery Archive collection we have called upon the generosity of today's owners of a small number of extant works by those artists who were living at the time their portrait was published. We are indebted to these owners who have enabled us to show twelve distinguished works side by side with our collection.

It is with considerable interest that we reveal these unexpected and diverse fruits of the collaboration between Gainsborough and Denvir and their many artist friends, executed during a period when graphic figuration was very unfashionable. Gainsborough and Denvir's encouragement of artists, particularly the young and unknown, made a significant contribution towards their appreciation by a wider audience. Twenty years after his death Gainsborough would be gratified to see how the general interest in the work of living artists has increased beyond recognition since that difficult post-war period.

We are indeed grateful to all those artists who so readily gave much time to answering our questions about their commissions and the general history and popularity of the magazine during the 50s and 60s. We would also particularly like to thank Bernard Denvir, Pierre Rouve, Donald Hamilton Fraser, Feliks Topolski, Mervyn Levy, and Frances Gillespie for assistance during the preparation of this book.

Nicholas Serota *Director*

Introduction

The self-portraits and portraits in this collection were published on the front page of the fortnightly *Art News & Review*, beginning with its first issue on 12 February 1949. There was a short written account of the artist with each illustration, usually mentioning a current exhibition, and each was numbered continuously, under the title 'Portrait of the Artist'. This was consciously borrowed from James Joyce's 'Portrait of the Artist as a Young Man' (1916) but inevitably then also recalled Dylan Thomas's autobiographical novel 'Portrait of the Artist as a Young Dog' (1940), and it is Thomas who seems now more appropriate, evoking an art world where writers and artists belonged equally, and which was centred on personal friendships and not as divided as later into mutually exclusive groups. Almost all the artists chosen were known personally to the founder of the magazine, Dr Richard Gainsborough, or to its first editor, Bernard Denvir. The appreciations were usually written by friends and, since they were expected to be read most carefully by the subject, were direct and factual and not as sharp as had been, for example, the texts with the caricatures of Spy and Ape in Vanity Fair, because the artists were mostly not yet personalities. William Rothenstein's books of portrait drawings with commentaries may have been a precedent, but the idea was original.

The Review owed its unlikely foundation to the meeting of Gainsborough and Denvir, both already wishing to produce a new art magazine in London. Richard Gainsborough, aged 55, had been a doctor of medicine in practice in Fletchling, Sussex, until his retirement in 1948. He was interested both in journalism and, as an enthusiastic amateur, in the arts. He had grown up with publishing as his family, who were Jewish, had founded and edited Jewish papers in Leeds and later in London. His connections with the arts came through his second wife, Eileen Mayo, who had been a pupil at the Slade School and with Léger in Paris. It seems that Gainsborough did not retire with the purpose of founding an art journal, but that he came to realise that there was a distinct lack of a paper that gave the information he needed: a report of the full range of art exhibitions showing in London. Bernard Denvir was then at the start of a career as art critic and art historian, which had been delayed by the war. He had already committed his mind to modern art after seeing as a boy the 'Unit 1' exhibition in Liverpool in 1934. He first published with the Oxford magazine *Counterpoint* in 1947–8. This magazine's connection with the neo-romantic artists was pursued by Denvir in articles in *The Studio*, *Connoisseur* and *Horizon*, and he became art critic for *The Tribune* and the *Daily Herald*. While living briefly in Paris he had used and admired the journal *Les Arts* published by the Wildenstein Gallery, which was cheap and informative, and which became his immediate model for the *Art News & Review*.

Dr Gainsborough first tried without success to purchase the Chelsea events and gossip magazine *SW3*. He lived at 33 Royal Avenue, Chelsea, and so had seen this fortnightly from its foundation in 1946. It had a large format, cost sixpence, and had an occasional 'art supplement' to which Denvir, who then happened to live two doors away from Gainsborough at 37 Royal Avenue, often contributed. The only rival to a new art magazine was *The Studio*, founded in the 1890s, which appeared monthly and cost 2/6. This had a small number of longish articles, often of Royal Academy taste, and did not attempt to cover newer art. Modern art criticism was published in the daily papers, the weeklies or in literary journals, none of which was intended for artists. Gainsborough determined to finance a new magazine himself, and in order to avoid possible difficulties from the American *Art News*, which had also been his own first choice of title, he called it *Art News & Review*. As this implied, it was to look like a newspaper, with large format, and no colour. The first issue was designed by Eileen Mayo. To find a distinctive front page Denvir decided to ask artists for self-portrait drawings, so giving the opportunity to

fig.1

Number of Galleries listed in 'Art News & Review' 1949–1968
Public and Private Galleries in Britain

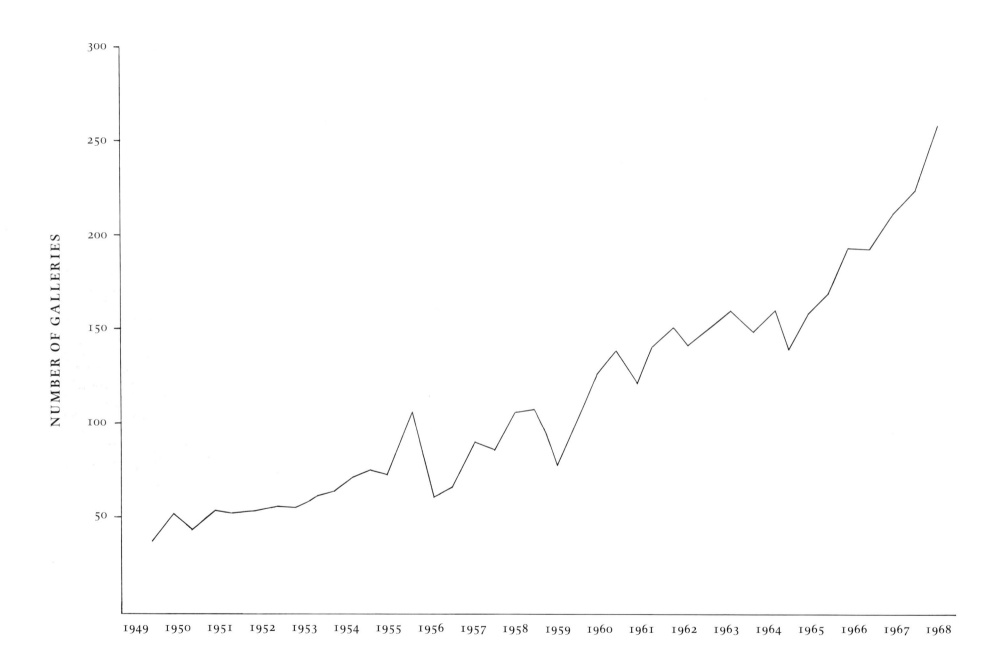

present a new artist in each issue and declare the Review's commitment to living artists. The series continued on the front page until January 1957, when the artists' portraits were transferred to an inside page.

The Review was produced from 33 Royal Avenue, which became a kind of unofficial club for Gainsborough's artist friends, until it moved to 19 Berkeley Street in about 1955. There was little formal arrangement, but Denvir as editor chose the artists for the front page and did much of the writing himself. The principal purpose of the Review was to list all, and review many, of the exhibitions current in Britain. The magazine still exists today, fulfilling the same useful function under its new title *The Arts Review*, first used by Gainsborough on 8 April 1961. At first there was no other periodical that gave gallery news, and although later there were more galleries and new publications there was still nothing that covered all types of exhibition and was not partisan. During the first ten years, the period of the self-portraits, the quality of writing was remarkable, and the Review was used by artists as an outlet for their criticism or statements. The necessity for such a publication, and its continuing value, is shown by the increase in the numbers of galleries listed over the period (see fig.1).

On the first birthday of the Review (11 February 1950) an unsigned editorial proudly gave its aim as:

> ... to be a *newspaper* of the arts in the full meaning and connotation of the word ... to give information ... the events, the movements and the personalities of the world of art.

The editorial went on to give a curiously neo-romantic appeal:

> Deep down in the roots of English cultural life there is a poetic source of inspiration, and this manifests itself in many works of art. It is because of our unflinching faith in the artistic genius of the people of these islands ... that the policy of this paper is to support ... the work of the British artist.

This nationalism was overtaken by the wider aims of the authors and artists, although it set some limits. For the authors it was claimed that the Review was building up an English school of criticism, which appears

fig.2 Dr Richard Gainsborough

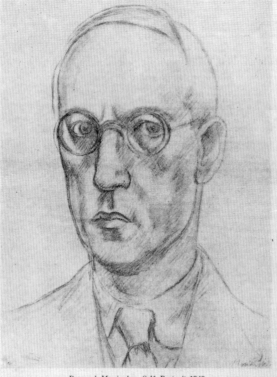

ART NEWS
AND REVIEW

VOL. 1 NO. 1 FEBRUARY 12 : 1949 FORTNIGHTLY 6d.

Portrait of the Artist No. 1.

BERNARD MENINSKY

IN THE art of any period there are always two processes at work. The one may be called discovery, the other digestion. One is visual and formal research, the other consolidation of what has been discovered, and the making of it into a foundation for future discovery and growth. Since modern painting during the last half century, has been highly inventive there has been a distressing tendency for these two processes to fly to extremes. Amongst certain painters of the 'research' type a belief has grown up not only that it is necessary to evolve a new style of painting peculiar to oneself, but that each work executed in this style must be an absolutely new statement, hysterical almost in the vehemence of its originality. The other kind of painters have tended too frequently to lapse into that inept acadamicism which mumifies rather than consolidates and offers nothing of value or importance to the growth of living art.

In this respect Bernard Meninsky is almost unique amongst contemporary English painters. The pattern of his growth has been logical, consistent, and similar in kind to that of an artist living in an age which possesses a tradition. His work is a touchstone for that of other English artists of his generation, a measure of their relation to the main stream of European art.

Born in Liverpool in 1891 Meninsky first went to the Liverpool School of Art. The cultural tradition of Liverpool was a distinguished one, the art school had a reputation for liveliness, and the Walker Art Gallery, though at that time by no means rich in living art, contained a fine collection of primitive Italian paintings. His enthusiasm also led Meninsky to attend the summer courses at the Royal College of Art in South Kensington.

Paris became an influence in his life, and though there must have been considerable contrast between the kind of work which was considered good on the banks of the Mersey, and its equivalent on the banks of the Seine, the contrast was one likely to stimulate rather than depress. After he left Liverpool, he went, almost inevitably for anyone who at this time really wanted to be an artist, to that English repository of the drawing tradition of Ingres, the Slade School of Art.

It is difficult to determine precisely what effect the Slade had on his draughtsmanship, but it cannot have done less then reinforce an artistic character which was based on the integrity of disciplined drawing. Meninsky is one of our most distinguished draughtsmen, and yet one who has always managed to allow his drawing to control and inform his painting without in any way permitting the bare framework of construction to obtrude through the rich plastic qualities of his paint.

As a teacher at the Westminster and the Central Schools of Art he has carried on the tradition of professional linear scholarship which was brought to England by Legros and carried on by Brown and Tonks, but, unlike a host of others, he has added to that tradition, and enriched it with the discoveries of the

successors rather than of the imitators of Ingres. He was nineteen when the first Post-Impressionist exhibition at the Grafton Galleries revealed to England that the discoveries of Manet and Renoir were not final ones, but the basis of further exploration.

Meninsky saw the revelation of Post-Impressionism, he understood the meaning of Cezanne, and henceforth his art was a digestion of that revelation and an explanation of it. Using a palette which owes something to the Fauves, and through them to the Expressionists, he has created a world of classical dignity and plastic form. In an essay which served as an introduction to an Arts Council exhibition 'The Art of Drawing' Meninsky wrote:— " but

colour yields its highest potentialities only when allied in an organic unity to the form which controls it. When this unity is missing, painting becomes purely decorative, or merely imitative, and there is no doubt that a superficial verisimilitude or mere surface decoration are both inferior forms of art." In the sense of this quotation he is a *unified* artist.

Works by Bernard Meninsky are to be seen in the following public collections:— Tate Gallery; British Museum; National Gallery of Ireland, Dublin; Manchester Art Gallery; Bradford Art Gallery; Aberdeen Art Gallery; galleries of Adelaide and Melbourne, Australia, Minnesota, Mass., U.S.A.

Bernard Meninsky—Self Portrait 1949.

fig.3 *Art News & Review*, 12 February 1949

in the event to have been justified, considering the names of the critics published during the 1950s.

The arrangements for requesting the self-portraits were as informal as everything else with the Review. The 'Journals' of the landscape painter William Townsend (now at University College Library, London) record the procedure in detail:

Monday 11 September 1950
Denvir rang up to say he wanted to do an article on me for the *Art News & Review* and wanted a self-portrait. As I had a drawing M. and I cycled over to Wittersham after supper to take it and have a chat. Back in the starlight; light glowing behind us from Dungeness and over Hastings and aureoles from the villages on the hills and from cars on distant roads. (vol.xx)

Denvir had then moved to Kent from London, and Townsend lived at Rolvenden near Canterbury. Denvir wanted a better drawing:

17 September 1950
Trying to make self portrait drawings, to offer an alternative to Denvir. The good drawing and poor likeness, or the other way, go obstinately together – and that seems true for most of the artists whose self-portraits have so far appeared in his review, though there have been consoling double failures.

19 September 1950
At last I got a good and not too solemn drawing done for Denvir's article.

The drawing in the Tate Gallery Archive was published on 21 October:

21 October 1950
Denvir has done a note on me, mostly biographical and harmless, and reproduced one of my drawings in *Art News & Review*.

Townsend seemed not particularly excited, but there was a surprising

reward, and a measure of the reasonable standing of the Review, when later in the week he was invited to lunch with Wyndham Lewis, Lilian Somerville (Director of Fine Arts at the British Council), the painter Aubrey Williams and Bernard Denvir. He had not before been a favourite of the British Council, but now:

27 October 1950
. . . I am almost persona grata with Mrs. S and her party . . .
general admiration for my drawing in *Art News*.

The finances of the Review, which ran at a loss against Gainsborough, were sustained by the advertisers, and it was a dispute over critical versus financial responsibilities for the advertising of commercial galleries, as well as perhaps mere restlessness, that led Denvir to leave in 1954. Denvir himself began a new fortnightly review, titled simply *Art*, which was first published on 26 November 1954. In an article here on 'The Art Papers of Britain' (15 June 1956) Denvir claimed that his paper was aimed at a wider audience outside London, including those with a less direct interest in the arts, but in July that year it ceased publication and was incorporated into the magazine for amateur painters *The Artist*. Meanwhile Gainsborough had been obliged to take over as editor of *Art News & Review* himself, and employed as his assistant the painter Donald Hamilton Fraser during 1954–5, who recalls at least one issue written almost entirely by himself under different names. From 1955 the critic, broadcaster and painter Mervyn Levy worked as associate editor on the Review, and as he was also at the same time art correspondent of the BBC he was able to mention exhibitions and the Review in broadcasts. Gainsborough and Levy in 1955 launched another periodical, *Modern Artist*, to be more of a magazine than a newspaper, but it only survived for three issues.

The continuous numbering of the 'Portrait of the Artist' ceased with number 183 (Kyffin Williams, 4 February 1956), and in the next issue F.E. McWilliam's drawing came under the same title but without a number. On 19 January 1957 Philip Sutton's portrait was printed on an inside

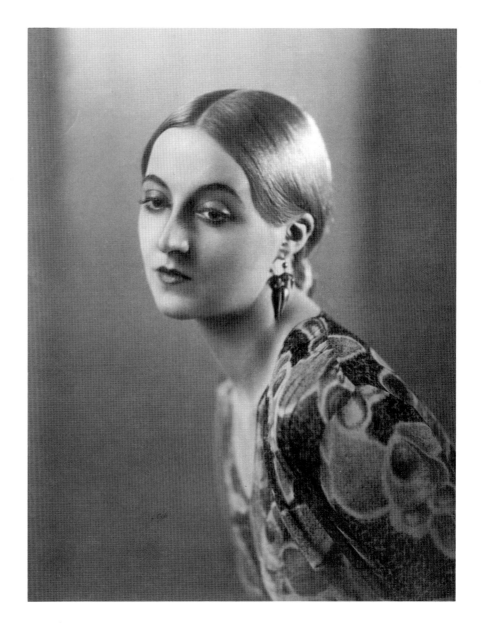

fig.4 Eileen Mayo

page, leaving as the leader on the front one of Eric Newton's articles on National Gallery paintings. The series continued inside the Review until the first break, which came in the issue of 8 November 1958. It was often interrupted during the following year, and the portraits when they were published were often photographs.

Richard Gainsborough ran the Review until he died, aged 73, in 1969. An obituary by Pierre Rouve, who was one of the most frequent authors but never worked for the Review, was published on 27 September. The architect John Gainsborough took over from his father and was in charge of the Review until 1978.

The collection of portraits of 96 artists – there are a few unknown, and some are in several versions – was acquired from John Gainsborough by the Tate Gallery Archive in 1982. During the decade from February 1949 to January 1959 the *Art News & Review* published about 227 portraits of modern artists (there were also portraits of old masters), and thus the collection exhibited is rather more than a third of the total published. Most of those missing were not made especially for the magazine but reproduced from already existing portraits, and included many of the foreign artists, and the older and better known, and more expensive, British artists, whose work could not very well have been requested.

It is evident from the quality of the portraits reproduced that the artists took the request seriously. The replies to a questionnaire sent to the artists this year by the Tate Gallery Archive showed most commonly gratitude for the enthusiasm of Richard Gainsborough, and gratitude also for the publicity at a time when so little was available. It is difficult to realise that even ten years after the war the London art world was still comparatively provincial, and although Patrick Heron, for example, recalls that the Review by his standards was not important he was happy to submit a self-portrait as it was 'a slight breakthrough on the benighted British scene'. For a few of these artists this request produced the only self-portrait they painted (as Josef Herman), and for others it remained one of only a very small number (Jan Le Witt, Anne Redpath, Hans Feibusch). A considerable number of the artists often painted portraits, but there were also those abstract artists later in the period who found the request an unusual challenge (Donald Hamilton Fraser, William Gear, Ralph Rumney). The variety of effect is always remarkable in a collection of self-portraits, particularly as here where the circumstances were so similar, and when so few of the artists thought it the occasion to be ambitious in style. An exception in terms of style was Eduardo Paolozzi, who submitted one of the agonised, wire-fence heads, comparable to the iron sculpture of Reg Butler, that he was then drawing. Michael Rothenstein, both in his self-portrait and his portrait of Edward Bawden, combined printed design, pencil drawing and photography into one attractive collage. The drawing by Peter Foldes is ambitious as a narrative with a larger context than a self-portrait, presenting the paradox of a realistic versus an abstract style. The collection is also an anthology of artists' dress. The bow-tie and beret were to some the uniform of the artist, but others studied the most ordinary clothes, and sat smoking a pipe and wearing a tweed jacket. In some cases an ordinary background was sought as well, as with the illustrators James Boswell, who placed himself in a pub, and Edward Ardizzone, seen turning the pages of a book in front of a bookcase with his spaniel beside him. Younger artists, like Paul Hogarth, wanted to appear informal in a pullover. The most idiosyncratic were able to adopt a character, as Pietro Annigoni with the stance of a high renaissance prince, or Anne Redpath with a plain directness that is possibly Scottish, or Cecil Collins as a precarious spirit. The artists were usually requested to send drawings, and the variety of touch in pencil and chalk is evident across the whole collection. The extraordinary backwards and forwards motion of Keith Vaughan's line, his pencil making short dashes, is comparable to the boundaries between colours in his semi-abstract paintings. Jean Hélion is unique in using the chalk as if it were a colour, in particular smudges across the page. It is interesting to compare a single feature between drawings. The representation of the artist's eye, for example, is so varied, yet always so convincing, as to demonstrate the impossibility of a unique match between touch and reality. The concentrating eyes of Merlyn Evans, John Minton and William Roberts, all drawn in a comparable but not identical way, somehow give access to different personalities.

Richard Gainsborough's unassuming wish that the Review should deal

with the whole of art as practised in Britain could not apply to the limited choice for his front page. The art world, although less fragmented then than in the 1930s, was still sufficiently divided for certain styles of work to be omitted, for instance the exhibitors at the Royal Society of Portrait Painters, which was active in the 1950s. The choice was mostly from modern artists, even though some who are now most valued are not included (whether through being omitted, or refusing). Amongst British artists there were few types of artist, as opposed to individuals, who were not represented. Of the comparatively few galleries showing younger British artists the Leicester Galleries, with up to three exhibitions every month, dominated. The selection is weak on sculptor's drawings, and not generous with artists from St Ives. It is impressive that so few of the artists listed are now forgotten. The selection of foreign artists, depending also on those who were exhibitors at London galleries, was very thin, although Gallery One, the New Vision Centre and the Matthiesen Galleries were showing foreign artists regularly. There were naturally hardly any Americans (Ben Shahn, Frederick Schaeffer), and more French than any others. Despite the enthusiasm in London for de Stael's exhibition at the Matthiesen Gallery in 1953 the abstract artists of the School of Paris were barely included, presumably because the Review was not sufficiently important in Paris for them to want to make a self-portrait. The contact in Paris was the critic Dora Vallier (the sister of Pierre Rouve), whose history of abstract painting was to be published in 1967. There were easy exchanges between artists in South Africa and London, and several South Africans working in London were included (and Gainsborough had lived in South Africa before coming to London).

The array of artists chosen for portraits in the *Art News & Review* is a particular view of those considered interesting within the decade, and includes a sufficient number to be significant. So far as changes of taste are concerned, as Enrico Baj replied to a recent enquiry from the Tate Gallery Archive about his self-portrait:

On my recollection the magazine was at that time quite prestigious, also abroad. But, you know, the taste and fashion are so variable, and sensibility too, that it is difficult to judge nowadays with the eyes of 30 years ago. The fellow who went to take a glance (like I did) at the archive of the Biennale in Venice, will get so astonished, that he will take a little before to feel better. (8 August 1988)

David Fraser Jenkins

Note

This book combines two functions. It is an item by item description and index of the 122 artists' portraits (mostly self-portraits) acquired by the Tate Gallery Archive in 1982, and it is published as an exhibition catalogue to coincide with the first showing of the works in the collections and those other portraits generously loaned to accompany the display at the Tate Gallery from 31 January–16 April 1989.

As the Contents page will demonstrate, the arrangement of this book is divided into seven parts beginning with the Director's Foreword, followed by David Fraser Jenkins' Introduction, and this editorial note. They precede the illustrated catalogue of the Archive collection, TGA 8214.1–122, in which every sitter is illustrated at least once. A separate but similarly styled section follows for the twelve works on loan and the two works from the Tate Gallery Modern Collection, all of which were featured as part of the *Art News & Review* series 'Portrait of the Artist'. The last section, bar the Index, is a chronological list of the self-portraits and portraits published by *Art News & Review* between 1949 and 1960 (and one in 1968). Each portrait published was accompanied by a text and where the authors are known they are listed.

Tate Gallery Archive Collection TGA 8214.1–122 A Catalogue

This section is arranged alphabetically by sitter, and in the few instances where the sitter has been portrayed by another artist this is given and cross-referenced in the Index. Each sitter has been allocated a full page, and each item has an accession number. In the cases where an artist executed more than one work, either in a variant or a different portrayal, each is given its own entry, the fullest entry being reserved for the work published. Similarly, it is this published work that usually features in the large illustrations. This leaves a few unreproduced works. Ten unpublished but identified works also have a full entry with illustration. In addition there are seven unidentified portraits which are placed at the end of the sequence as nos 116–122. We would be very pleased to receive any information leading to their identification.

Dates of works are indicated immediately after the title, if the work is signed and dated by the artist. Dates in square brackets after the title are taken from the caption used by *Art News & Review*. For undated but published works the nearest date that can be established as a terminus post quem is the date of publication. Sizes are given in millimetres and then in inches in brackets, height before width.

Unless otherwise stated all inscriptions are taken from the recto and are by the artist. Framing instructions and inscriptions not by the artist on the verso have been omitted.

The publication date of the portraits in *Art News & Review* is given beginning with the abbreviation 'AN & R'....

Where it has been possible to identify an exhibition contemporary with the publication of the portrait this has been included, but the portrait was not necessarily shown at that exhibition. Biographies can only give an indication of a few teaching posts, and only the most recent or extensive solo exhibition.

Every effort has been made to contact copyright holders of the portraits published in this book. In those few cases where they have not been traced, the Tate Gallery Archive would be grateful to hear from anyone who has information that would lead to their discovery.

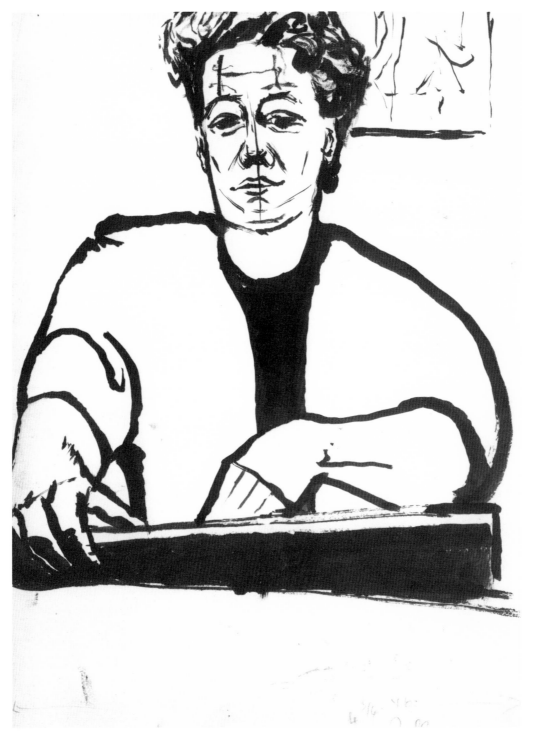

Kathleen Allen 1910–1983

Self-Portrait [1955] 8214.1

Ink and gouache on paper 394 × 286
($15\frac{1}{2} \times 11\frac{1}{4}$)
Not inscribed
AN & R, 12 November 1955, vol.7,
no.21, text anon.

Exhibition at Zwemmer Gallery,
October–November 1955.

Landscape painter, member of Artists'
International Association, Head of Art
and Design at Goldsmiths' College.
Retrospective exhibition, South London
Art Gallery, September 1983.

Pietro Annigoni 1910–1988

Self-Portrait 1953 8214.2

Ink and wash on paper 410 × 290
($16\frac{1}{8} \times 11\frac{3}{8}$)
Inscribed 'Londra LIII' and artist's
monogram
Sketch of a head on reverse, pencil
AN & R, 25 July 1953, vol. 5, no. 13, text
by Mary Sorrell

Portrait, landscape and fresco painter,
born in Milan, lived in Florence, society
portrait painter in Britain in 1950s,
portrait of H.M. The Queen exhibited
RA 1955.

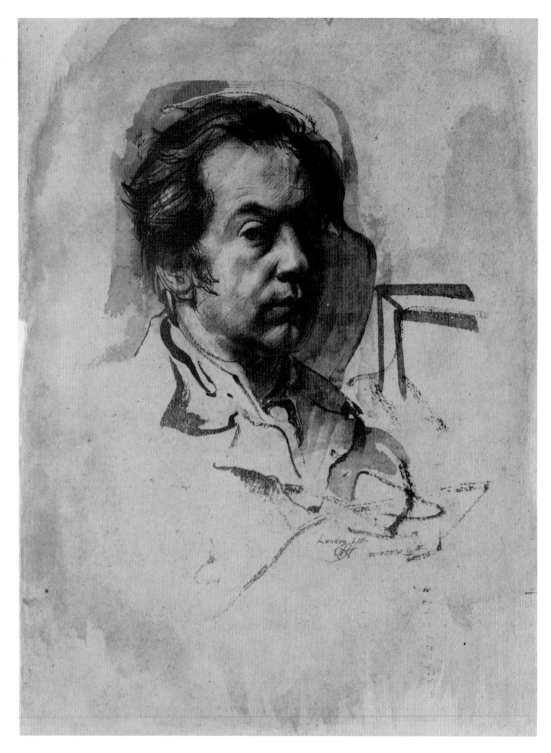

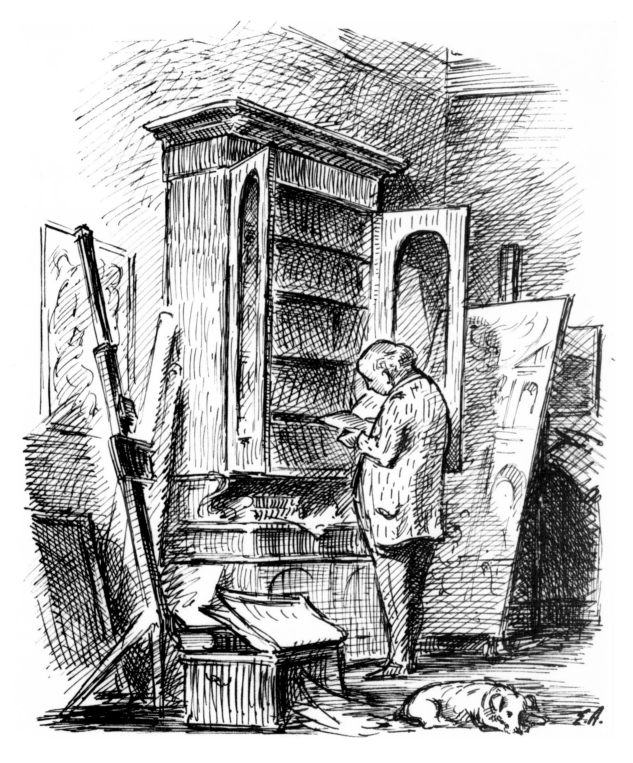

Edward Ardizzone 1900–1979

Self-Portrait [1952] 8214.3

Ink on paper 191 × 165 (7½ × 6½)
Inscribed 'E.A.' b.r.
AN & R, 28 June 1952, vol.4, no.11,
text anon.

Self-Portrait 8214.4
Pencil and biro on paper 334 × 267
(13⅛ × 10½)
Sketch of head on reverse – biro
Not published

Watercolour painter and illustrator,
especially of children's books and for
the Radio Times. War artist, teacher of
book illustration at Camberwell School
of Arts and Crafts. Retrospective
exhibition, Scottish Arts Council,
Edinburgh, December 1979–January
1980.

Walter Battiss 1906–1982

Self-Portrait 1956 8214.5

Ink on paper 381 × 267 (15 × 10½)
Inscribed 'Battiss' on shoulder and
'WALTER BATTISS' b.l., on reverse 'Art
News 56'
AN & R, 4 August 1956, vol.8, no.14,
text anon.

Exhibition at Imperial Institute, August
1956.

Painter and wood engraver, born in
South Africa, Head of Fine Arts,
Pretoria University. Retrospective
exhibition, Art Museum, Pretoria,
September–October 1979.

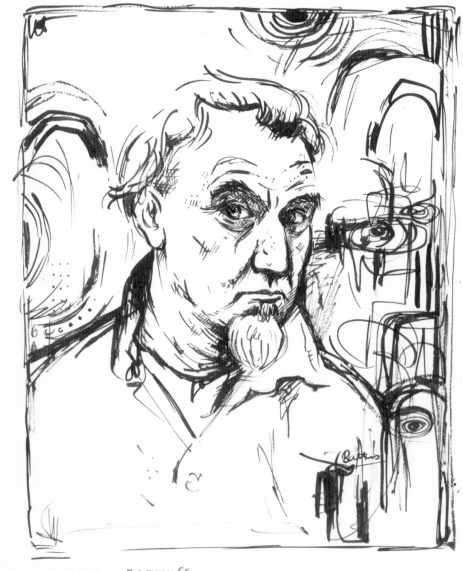

WALTER BATTISS.

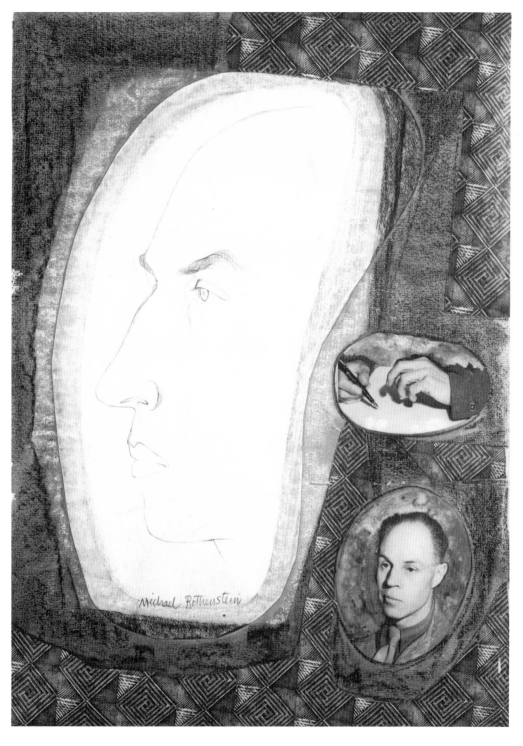

Edward Bawden b.1903

A Portrait Composition 8214.6
by Michael Rothenstein b.1908

Collage, pastel, pencil, printed papers
and photographs 457 × 330 (18 × 13)
Inscribed 'Michael Rothenstein' b.l.
AN & R, 12 August 1950, vol.2, no.14,
text by D.P. Gossop

Watercolour painter, illustrator and
designer, expecially of British landscape
and architectural subjects, member of
7 & 5 Society 1932–34, has lived in
Great Bardfield, Essex from 1935.
Retrospective exhibition, Herbert Read
Gallery, Canterbury, October 1988.

Michael Blaker b.1928

Self-Portrait 1951 8214.7

Ink on paper 195 × 154 (7⅝ × 6⅛)
Inscribed 'Michael Blaker '51' b.l., on
reverse 'Michael Blaker, Namrick
Studio, Namrik Mews, St. Aubyns,
Hove, Sussex'
Not published

Etcher and writer, studied at Brighton
College of Art.

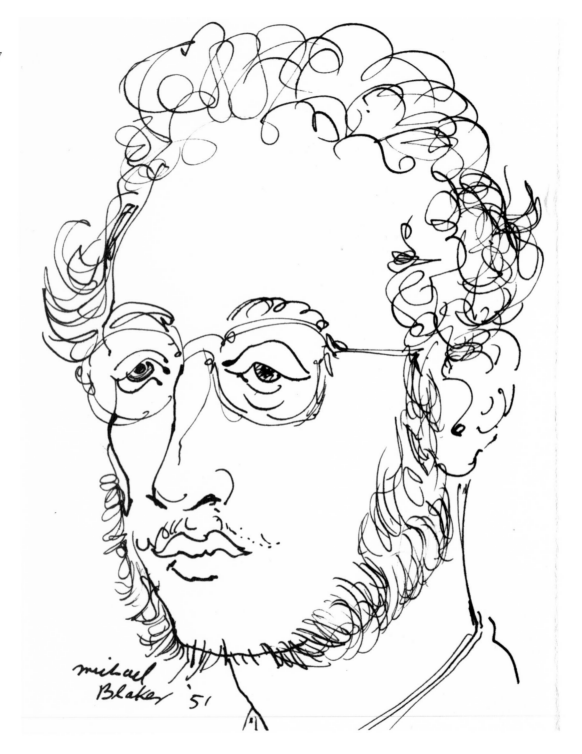

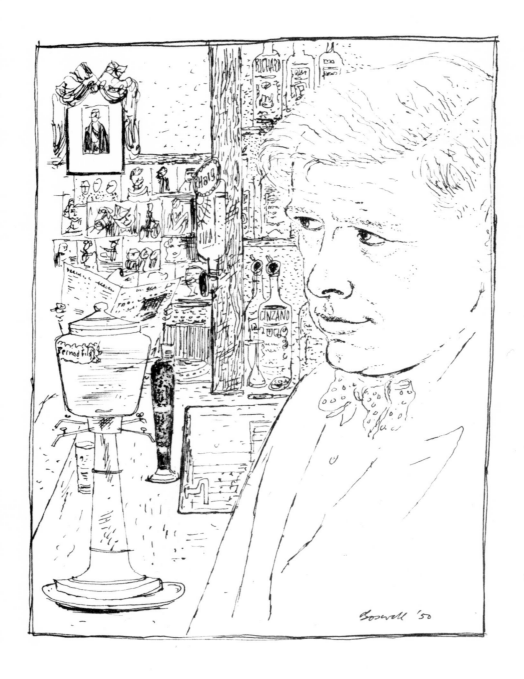

James Boswell 1906–1971

Self-Portrait 1950 8214.8

Ink on paper 254 × 207 (10 × 8⅛)
Inscribed 'Boswell '50' b.r.
AN & R, 18 November 1950, vol.2,
no.21, text anon.

Painter and illustrator, especially of
political subjects, born in New Zealand,
moved to Britain in 1925. Chairman of
Artists' International Association,
1944. Retrospective exhibition,
Nottingham University Art Gallery,
November–December 1976.

Theodore Brenson 1892–1959

Self-Portrait 8214.9

Watercolour on paper 255 × 194
(10 × 5⅞)
Insribed 'Brenson' b.r.
AN & R, 16 August 1958, vol.10, no.15,
text by Reginald Devigne

Exhibition at Drian Gallery, July–
August 1958.

Author and illustrator, abstract
painter, born in Latvia, worked in Paris
and U.S.A., Professor, Wooster, Ohio.

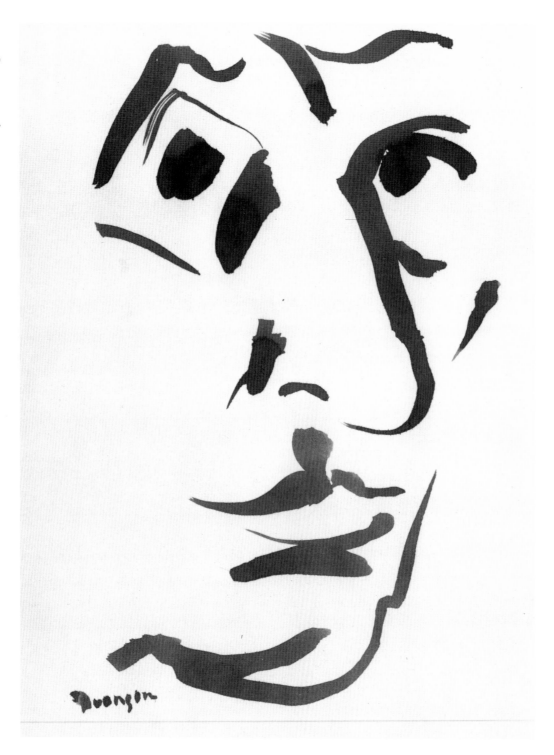

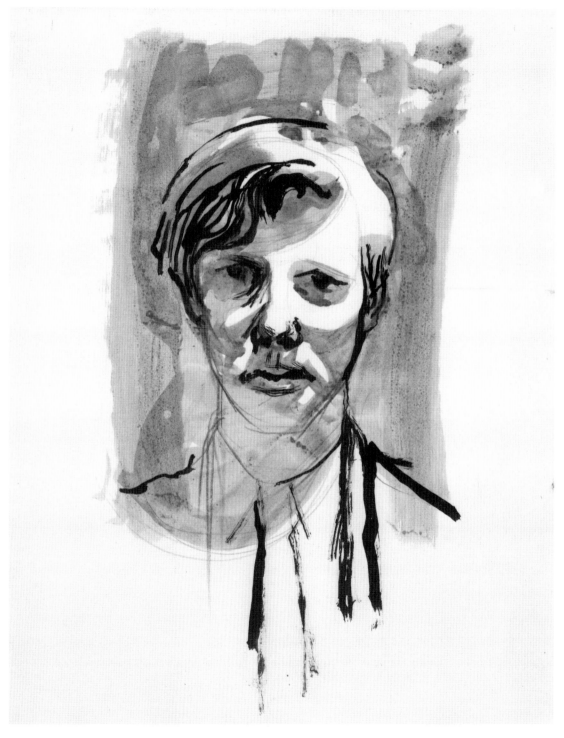

Morley Bury b.1919

Self-Portrait 8214.10

Pencil and watercolour on paper
492 × 406 (19½ × 16)
Not inscribed
AN & R, 24 May 1958, vol.10, no.9, text
by Michael Chase

Exhibition, 'Paintings', Zwemmer
Gallery, May 1958.

Landscape painter, member of Artists'
International Association.

Siegfried Charoux 1896–1967

Self-Portrait 1953 8214.11

Ink on paper 387 × 283 ($15\frac{1}{4}$ × $11\frac{1}{8}$)
Inscribed 'Charoux 1953' b.r.
AN & R, 16 July 1954, vol.6, no.12, text
by Mary Sorrell

Other versions, not published:

Self-Portrait 1953 8214.12
Watercolour on paper 387 × 283
($15\frac{1}{4}$ × $11\frac{1}{8}$)
Inscribed 'Charoux 1953' b.r.

Self-Portrait 1953 8214.13
Ink on paper 394 × 280 ($15\frac{1}{2}$ × 11)
Inscribed 'Charoux 1953' b.r.

Sculptor for architecture and in
terracotta, born in Vienna, came to
Britain in 1935; numerous public
commissions in London and Vienna.
Retrospective exhibition, Ashgate
Gallery, Farnham, May–June 1975.

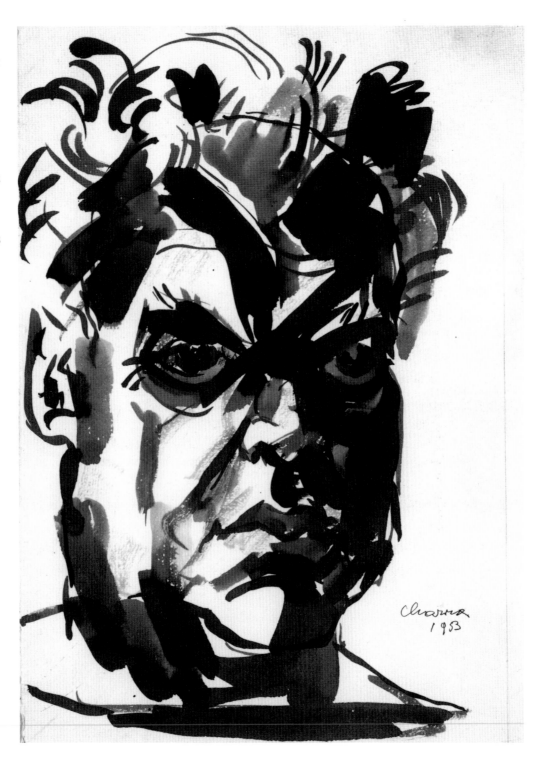

[28]

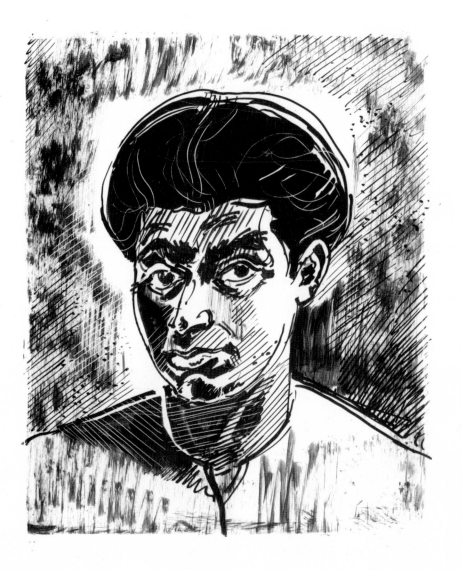

Shiavax Chavda b.1914

Self-Portrait 8214.14

Scraperboard with indian ink additions
267 × 210 (10½ × 8¼)
Not inscribed
Not published

Born in India, pupil at Slade School and
Paris. Exhibited paintings and drawings
of India at Artists' International
Association Gallery, 1955.

Harold Cheesman 1915–1982

Self-Portrait [1958] 8214.15

Ink on paper 305 × 215 (12 × 8½)
Not inscribed
AN & R, 13 September 1958, vol. 10,
no. 17, text by William Calvert

Other versions, not published:

Self-Portrait [1958] 8214.16
Ink on paper 375 × 275 (14¾ × 10⅞)

Self-Portrait 1958 8214.17
Charcoal on paper 336 × 204 (13¼ × 8)
Inscribed on reverse 'Harold Cheesman
Self-Portrait 1958' b.l.
Another self-portrait on reverse,
watercolour.

Exhibition at Zwemmer Gallery,
September–October 1958.

Landscape painter, Head of Fine Art,
Farnham School of Art. Retrospective
exhibition, West Surrey College of Art
and Design, Farnham, November
1980.

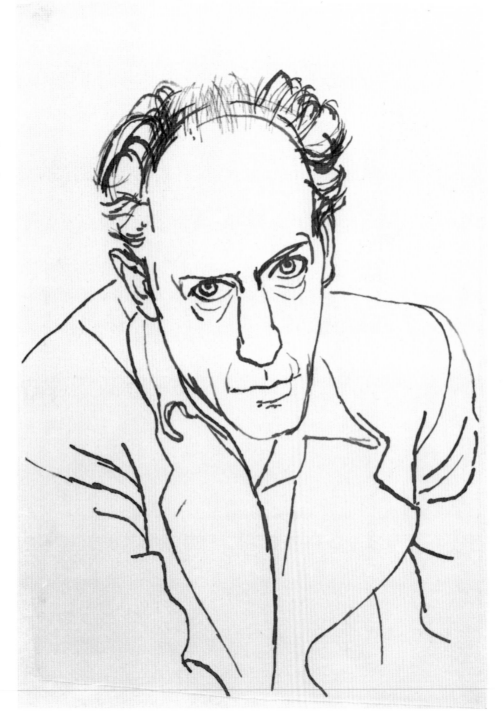

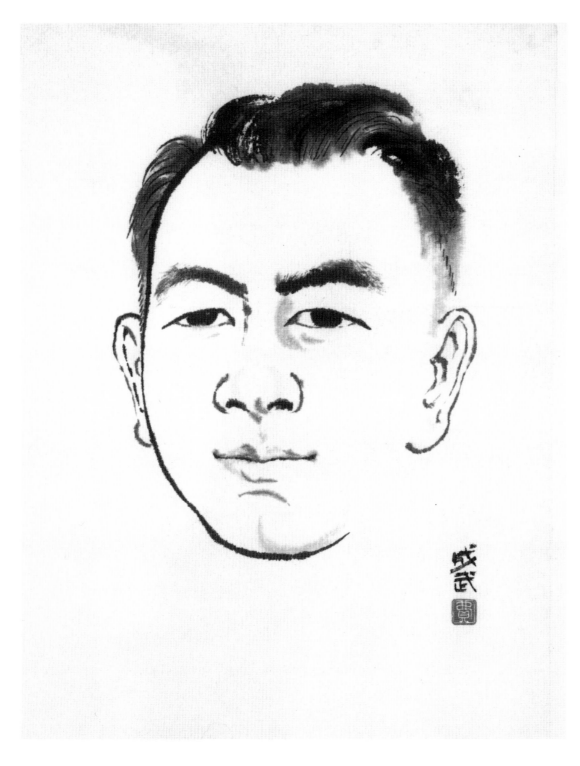

Cheng-Wu Fei b.1914

Self-Portrait [1953] 8214.18

Ink and watercolour with white
highlights on paper 330 × 254
(13 × 10)
Stamped with monogram b.r.
AN & R, 7 February 1953, vol.5, no.1,
text by Mary Sorrell

Another version, not published:

Self-Portrait 8214.19
Watercolour on paper 239 × 197
(9⅜ × 7¾)
Inscribed 'Self Portrait by C. W. Fei' b.r.
and stamped with monogram b.r.

Exhibition at Leicester Galleries, 1953.

Painter and illustrator, born in China,
student at Slade School from 1948.

John Christoforou 1921–1984

Self-Portrait 8214.20

Charcoal on paper 381 × 280 (15 × 11)
Inscribed 'Christoforou' b.r.
AN & R, 25 October 1958, vol.10,
no.20, text by John Coplans

Exhibition at Gallery One, October
1958.

Semi-abstract figure painter,
established Gallery One with Victor
Musgrave, lived in Paris from 1957.
Retrospective exhibition, Maison de la
Culture, Saint Etienne, March–May
1979.

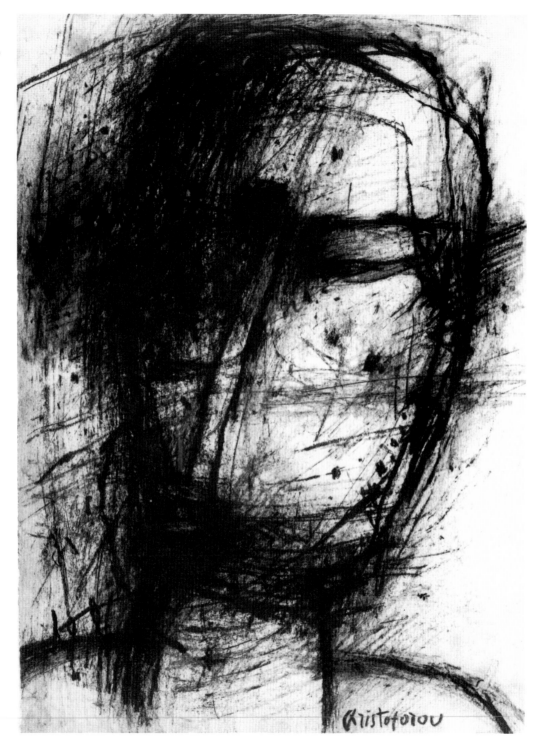

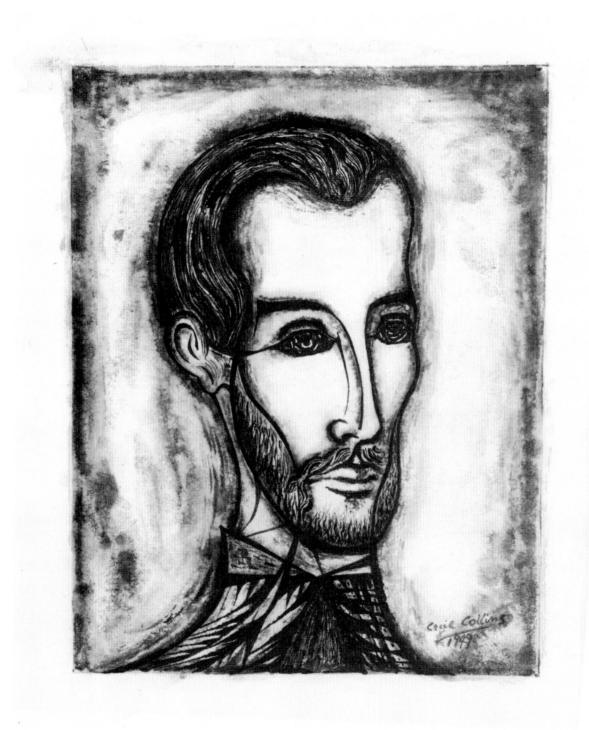

Cecil Collins b.1908

Self-Portrait 1949 8214.21

Ink and wash on paper 277×230
$(10\frac{7}{8} \times 9)$
Inscribed 'Cecil Collins 1949' b.r. and
on reverse 'Cecil Collins August
Cambridge 1949'
AN & R, 3 December 1949, vol.1, no.22,
text by Bryan Robertson

Exhibition, 'New Paintings', Heffer
Gallery, Cambridge, January 1950.

Painter and draughtsman of
imaginative figures in landscape.
Retrospective exhibition, Tate Gallery,
1989.

Ithell Colquhoun 1906–1988

Self-Portrait 8214.22

Ink and wash on paper 458 × 324
(18 × 12¾)
Not inscribed
AN & R, 19 September 1953, vol.5,
no.17, text anon.

Exhibition at Heffer Gallery, Cambridge,
April 1957.

Surrealist painter and author, lived in
Cornwall from 1950. Retrospective
exhibition, Exeter City Art Gallery,
1972.

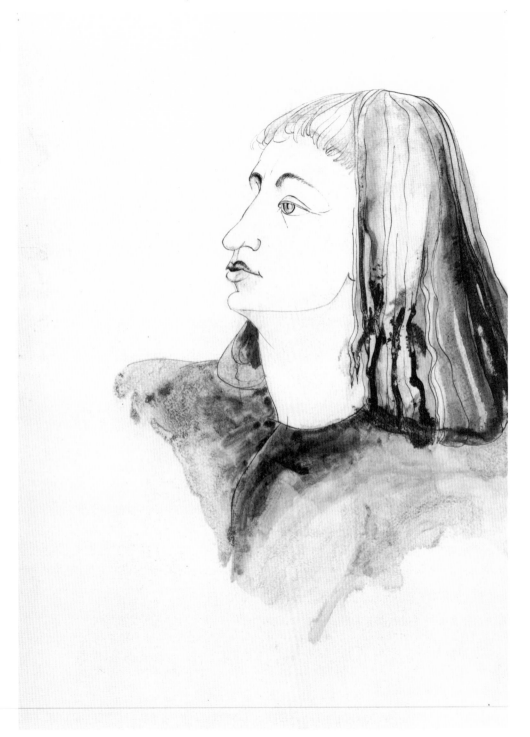

Milein Cosman b.1921

Self-Portrait [1957] 8214.23

Litho chalk on paper 257 × 241
(10⅛ × 9½)
Inscribed 'Cosman' b.r.
AN & R, 27 April 1957, vol.9, no.7, text
anon.

Exhibition at Matthiesen Gallery, May
1957.

Illustrator and print-maker, especially
of musical subjects, born in Germany,
pupil at Slade School.

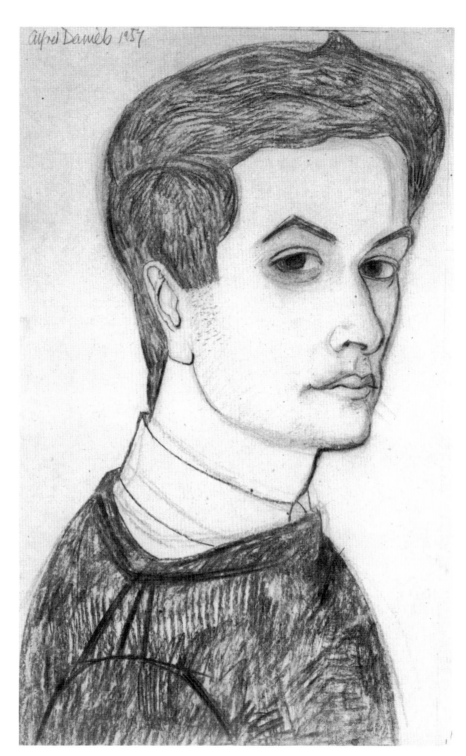

Alfred Daniels b.1924

Self-Portrait 1957 8214.24

Charcoal and white chalk on paper
507 × 315 (19⅞ × 12⅜)
Inscribed 'Alfred Daniels 1957' t.l.
AN & R, 2 March 1957, vol.9, no.3, text
by Charles S. Spencer

Exhibition at Zwemmer Gallery,
February 1957.

Painter of townscapes and workers,
teacher at Sir John Cass School of Arts
and Royal College of Art.

Alan Davie b.1920 - 2014

Self-Portrait 8214.25

Ink on paper 254 × 204 (10 × 8)
Not inscribed
Not published

Painter of abstract mythological
subjects, lives in Britain and West
Indies. Retrospective exhibition, Royal
Scottish Academy, Edinburgh, August–
September 1972.

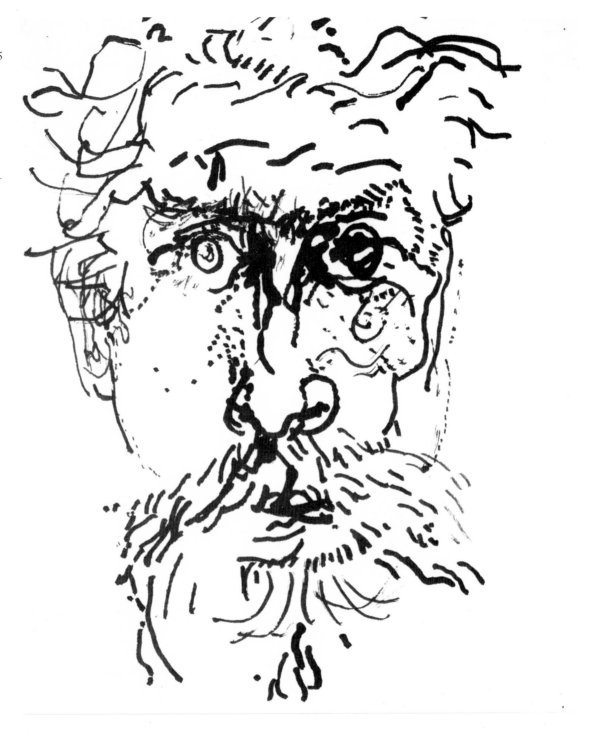

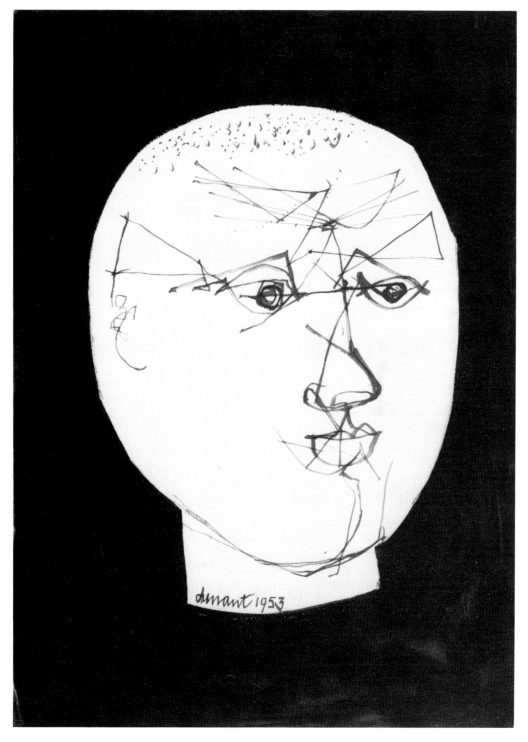

Roy Turner Durrant b.1925

Self-Portrait 1953 8214.26

Poster paint on paper 381 × 280
(15 × 11)
Inscribed on neck 'durrant 1953'
Not published

Abstract and figurative painter,
exhibited at Artists' International
Association Gallery in 1950s.

Edwards

Self-Portrait 8214.27

Charcoal on paper 334 × 271
($12\frac{1}{4}$ × $10\frac{5}{8}$)
Inscribed 'Edwards' b.l.
Not published

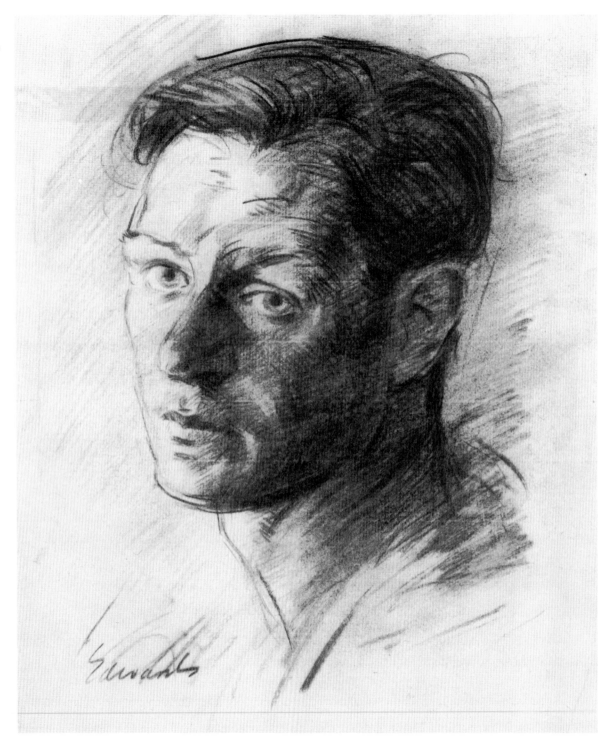

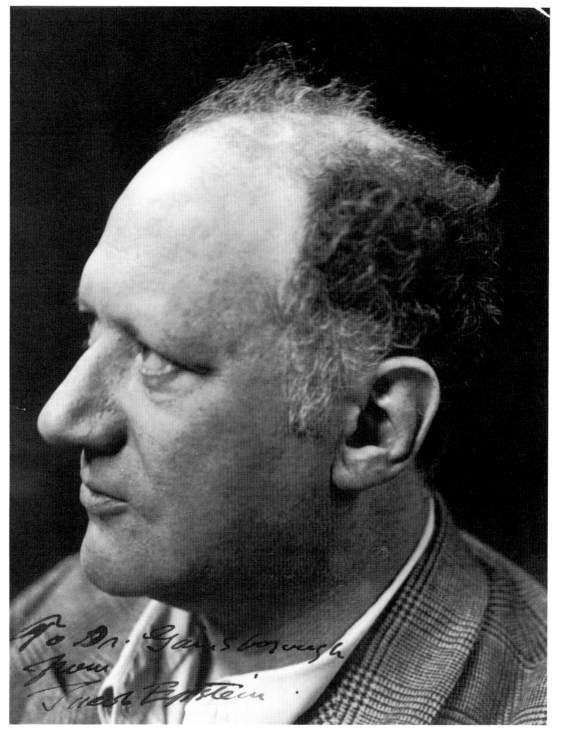

Sir Jacob Epstein 1880–1959

Photograph 8214.28

Photograph 244 × 197 (9$\frac{3}{8}$ × 7$\frac{3}{4}$)
Inscribed 'To Dr. Gainsborough from
Jacob Epstein' b.l.
Not published

Monumental and portrait sculptor,
born Brooklyn, New York. Studied
Paris, settled London 1905, made
abstract and vorticist works, founder
member London Group 1913.
Retrospective exhibition, Arts Council,
Tate Gallery 1952.

Merlyn Evans 1910–1973

Self-Portrait 1952 8214.29

Pencil on paper 520 × 380 (20½ × 15)
Inscribed 'Evans 52.' on lapel
AN & R, 23 February 1952, vol.4, no.2,
text anon.

Exhibition, 'Watercolours and
Drawings'. Leicester Galleries, February
1952.

Figurative and abstract painter and
etcher, pre-war surrealist.
Retrospective exhibition, National
Museum of Wales, Cardiff, June –
August 1974.

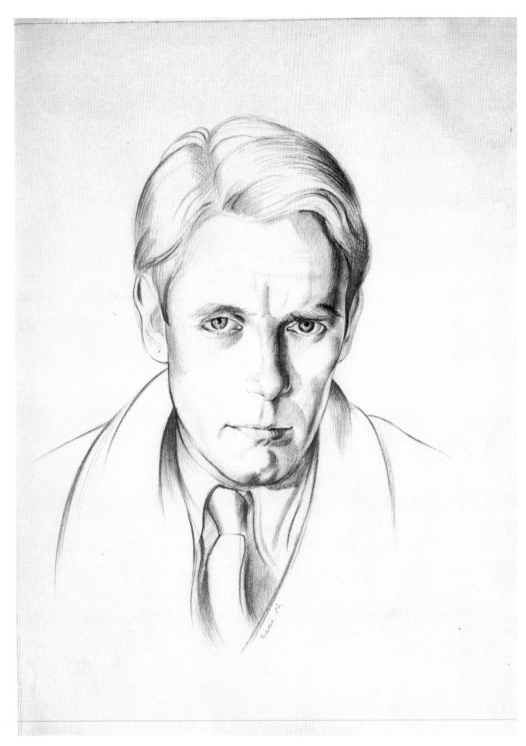

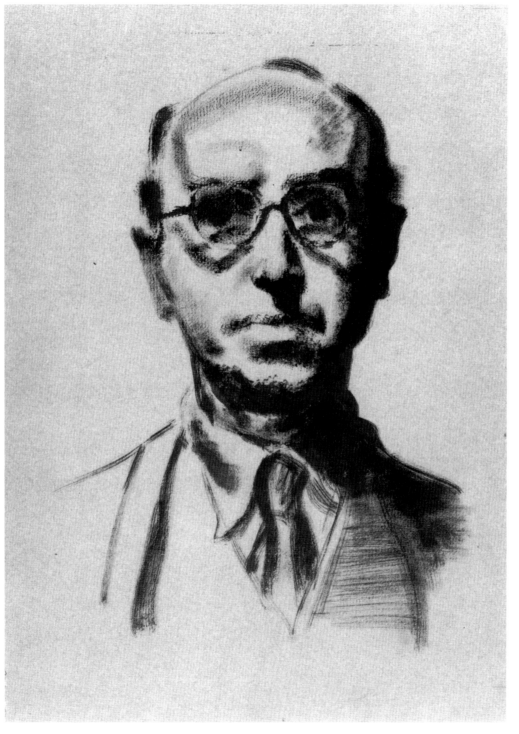

Hans Feibusch b.1898

Self-Portrait 8214.30

Poster paint on paper 312 × 223
($12\frac{1}{4} \times 8\frac{3}{4}$)
Not inscribed
AN & R, 24 February 1951, vol.3, no.2,
text anon.

Mural painter and sculptor, born in
Frankfurt, moved to Britain 1933,
numerous commissions for churches
and public buildings in Britain.

Peter Foldes b.1924

Self-Portrait [1953] 8214.31

Charcoal on paper 579 × 394
(22¾ × 15½)
Not inscribed
AN & R, 21 February 1953, vol.5, no.2,
text by Ronald Alley

Exhibition at Hanover Gallery,
February 1953.

Painter and film-maker, born in
Budapest, student at Courtauld
Institute from 1946 and also at the
Slade School. Returned to Hungary to
make films.

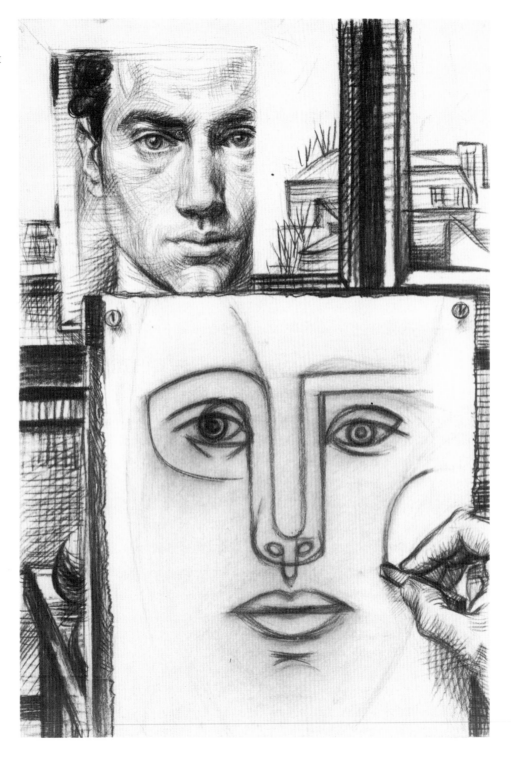

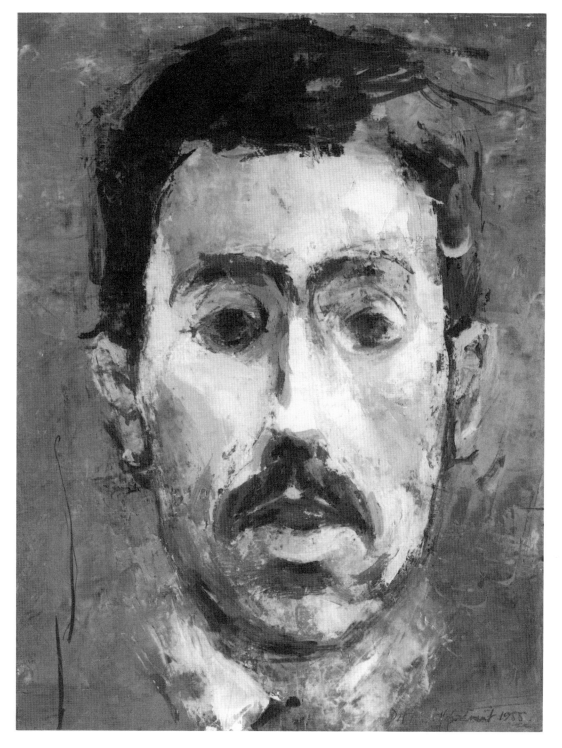

Donald Hamilton Fraser
b.1929

Self-Portrait 1955 8214.32

Oil on paper 256 × 196 (10⅛ × 7¾)
Inscribed 'DHF Self-Portrait 1955' b.r.
AN & R, 17 September 1955, vol.7,
no.17, text anon.

Exhibition, 'Eric Newton's Choice',
Tooth's Gallery, September–October
1955.

Abstract and landscape painter, lived in
Paris 1952–3, taught at Royal College
of Art 1958–1983.

William Gear b.1915

Self-Portrait 1949 8214.33

Ink on paper 498 × 324 ($19\frac{5}{8}$ × $12\frac{3}{4}$)
Inscribed 'Gear 49' and on reverse
'Gear 49'
Self-Portrait painted over on reverse,
ink and watercolour
Not published
Another version published, AN & R, 18
April 1953, vol.5, no.6, not in TGA
8214

Abstract painter, lived in Paris, 1947–
50, member of Cobra Group, Head of
Fine Art, Birmingham Polytechnic to
1975.

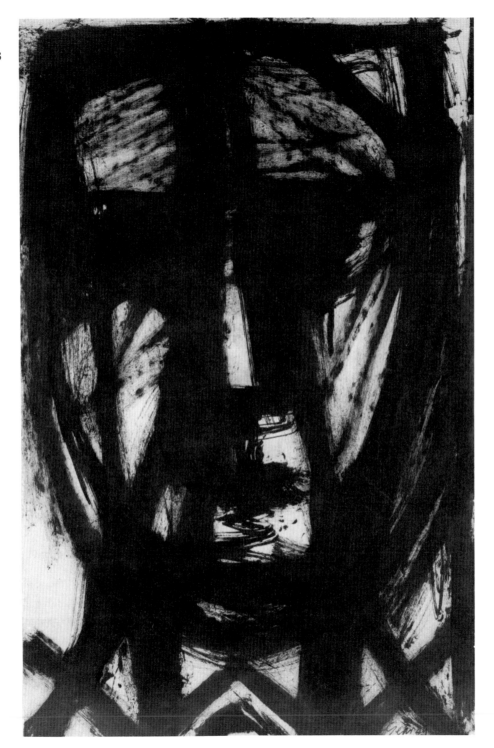

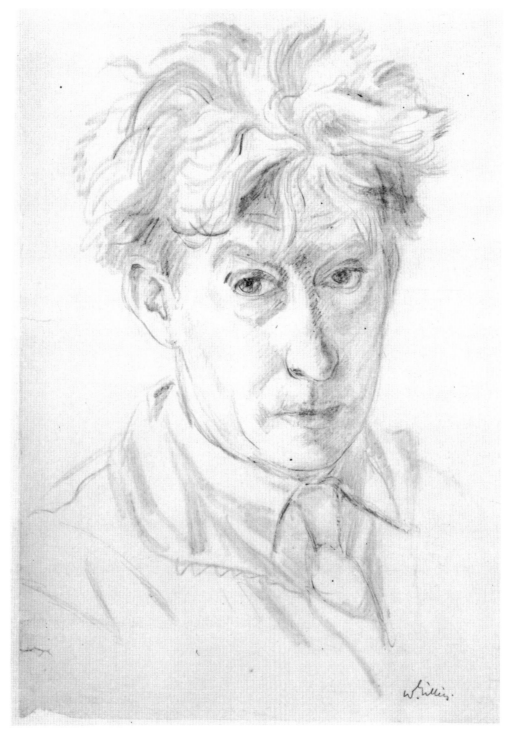

Sir W.G. Gillies 1898–1973

Self-Portrait 8214.34

Pencil on paper 345 × 240 (13⅝ × 9½)
Inscribed 'W. Gillies' b.r.
AN & R, 22 August 1953, vol.5, no.15,
text by David Cleghorn-Thomson

Group exhibition, National Trust for
Scotland, Edinburgh, August 1953.

Landscape and interior painter, taught
at Edinburgh College of Art from 1926,
Principal 1961–6.

Renato Guttuso 1912–1988

Self-Portrait [1955] 8214.35

Ink on paper 400 × 299 ($15\frac{3}{4} \times 11\frac{3}{4}$)
Inscribed 'Guttuso' b.r.
AN & R, 2 April 1955, vol.7, no.5, text
by Pierre Rouve

Exhibition, 'Recent Works', Leicester
Galleries, March 1955.

Figure painter and draughtsman, born
in Sicily and worked in Rome, leader of
social realist group, exhibited in
London from 1950. Retrospective
exhibition, Cittadella dei Musei,
Cagliari, July–September 1986.

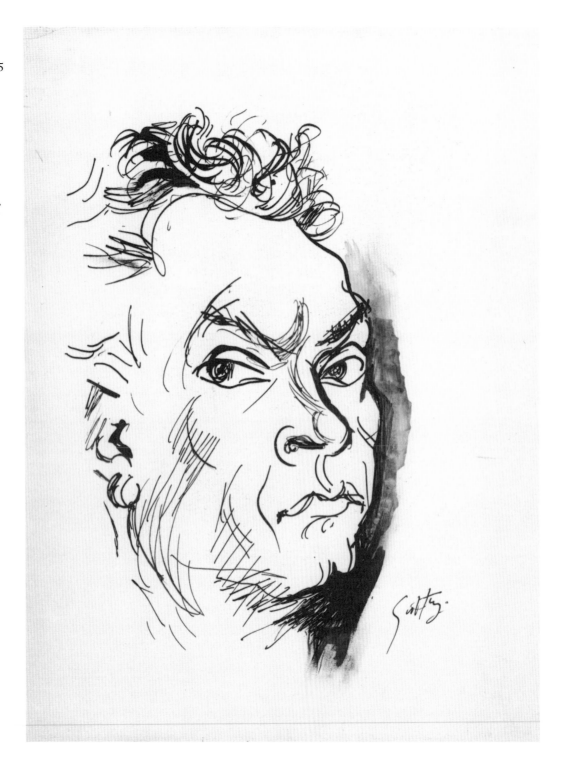

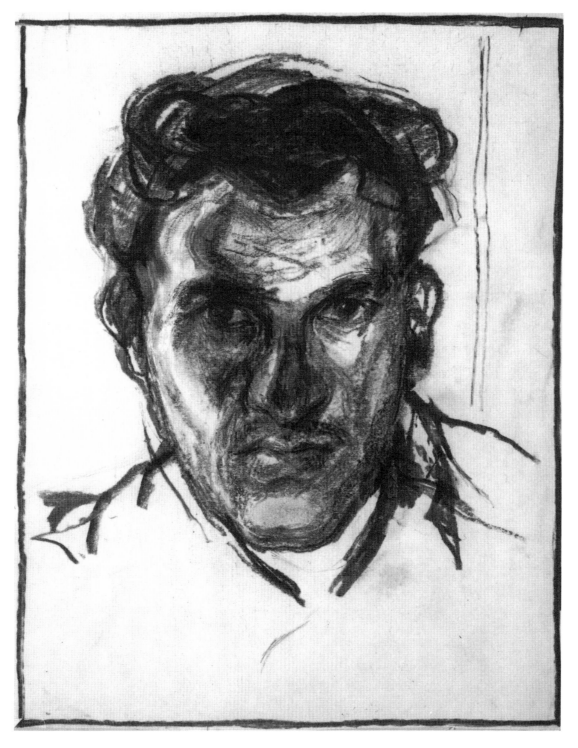

Alfred Harris b.1930

Self-Portrait [1955] 8214.36

Wax crayon, charcoal and chalk on
paper 356 × 270 (14 × 10⅝)
Not inscribed
Sketch of a cat on reverse, watercolour
AN & R, 10 December 1955, vol.7,
no.23, text anon.

Exhibition at Ben Uri Gallery, December
1955.

Landscape, figure painter and print-
maker, teacher at Institute of
Education, University of London.

Jean Hélion 1904–1987

Self-Portrait 1951 8214.37

Charcoal on paper 440 × 308
($17\frac{3}{8} \times 12\frac{1}{8}$)
Inscribed 'H. '51' b.r.
AN & R, 5 May 1951, vol.3, no.7, text
by A.D.B. Sylvester

Exhibition, 'Paintings', Hanover
Gallery, April–May 1951.

French abstract and figure painter.
Retrospective exhibition, Lenbachhaus,
Munich, August–October 1984.

© DACS 1988

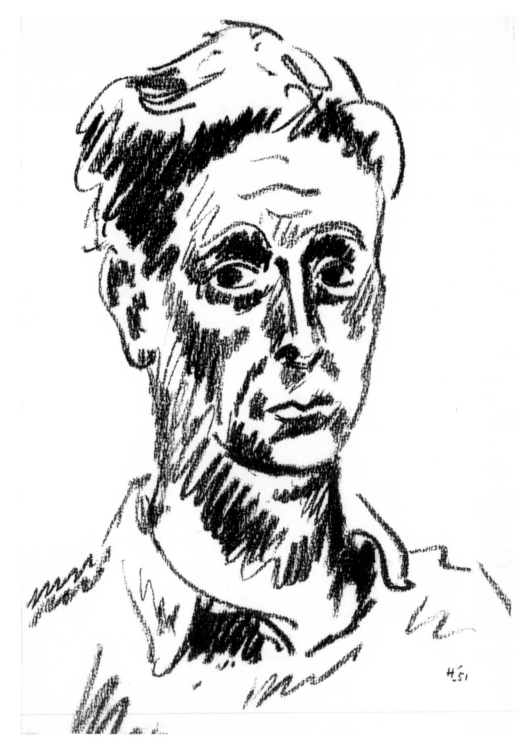

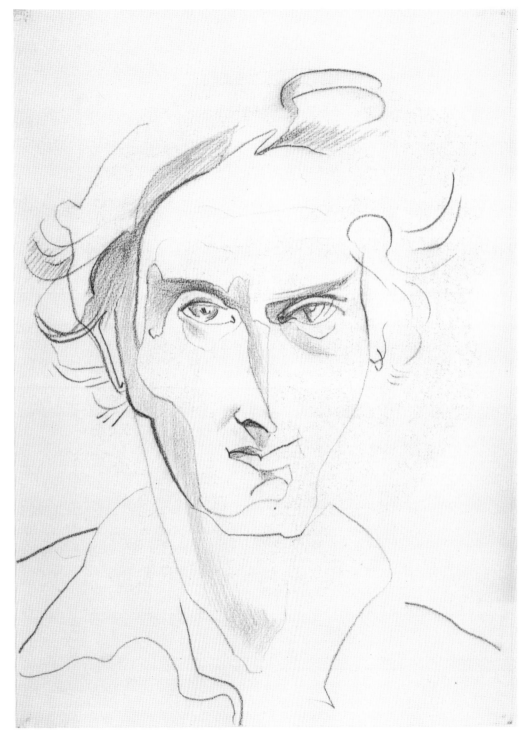

Gertrude Hermes 1901–1983

Self-Portrait [1949] 8214.38

Charcoal on paper 362 × 257
($14\frac{1}{4}$ × $10\frac{1}{8}$)
Not inscribed
AN & R, 26 February 1949, vol.1, no.2,
text by D.W.

Wood engraver and sculptor in wood,
pioneer of revival of wood engraving in
Britain. Wife of Blair Hughes-Stanton.
Retrospective exhibition, RA,
September–October 1981.

Ivon Hitchens 1893–1979

Self-Portrait 8214.39

Ink on paper 181 × 150 (7⅛ × 5⅞)
Not inscribed
AN & R, 4 November 1950, vol.2,
no.20, text by Mary Sorrell

Exhibition, 'New Paintings by Ivon
Hitchens', Leicester Galleries,
November 1950.

Painter of semi-abstract landscapes in
strong colours, member of 7 & 5 Society
1922–35. Retrospective exhibition,
Royal Academy, March–April 1979.

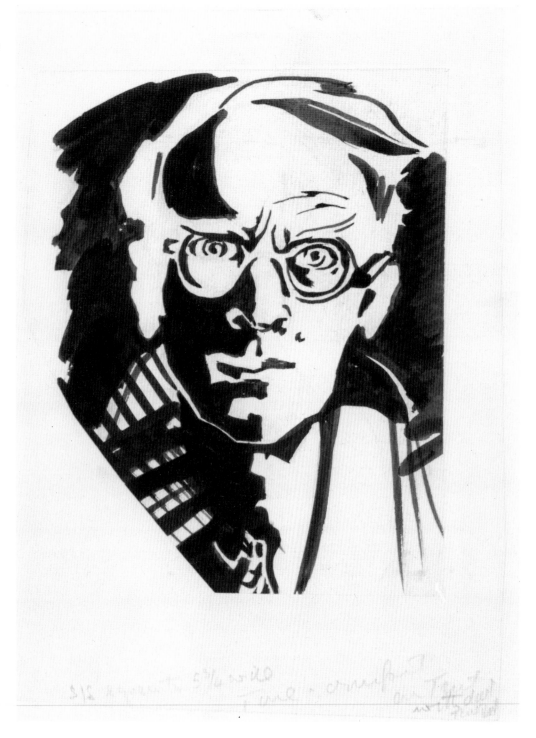

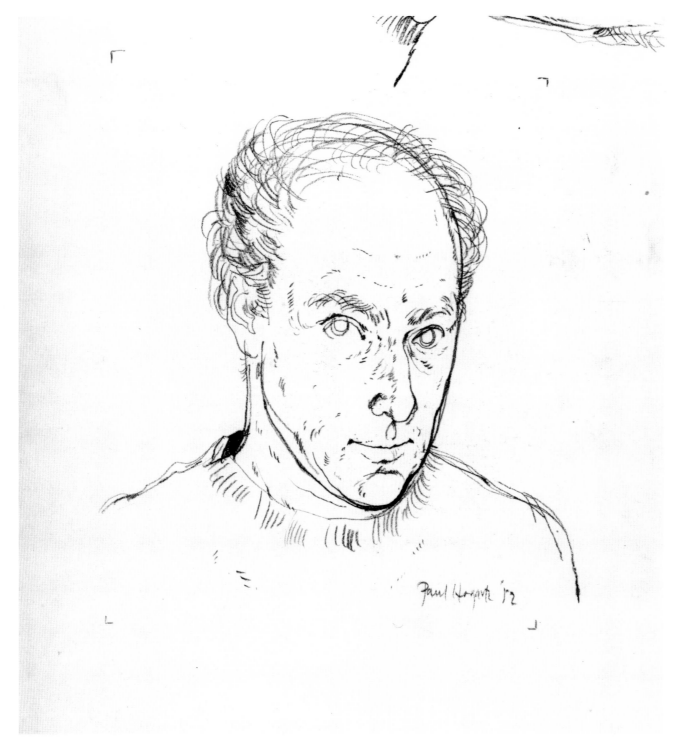

Paul Hogarth b.1917

Self-Portrait 1952 8214.40

Litho chalk on paper 296 × 277
($11\frac{5}{8} × 10\frac{7}{8}$)
Inscribed 'Paul Hogarth '52' b.r.
Sketch of torso on reverse, litho chalk
AN & R, 13 December 1952, vol.4,
no.23, text by John Berger

Exhibition, 'Drawings of Greece by Paul
Hogarth', Galerie Apollinaire, London,
December 1952.

Painter, print-maker and illustrator,
especially associated with his world
wide travels. Retrospective exhibition,
Abbot Hall Art Gallery, Kendal, July–
September 1985.

Blair Hughes-Stanton

1902–1981

Self-Portrait 8214.41

Ink monoprint 483 × 355 (19 × 14)
Not inscribed
AN & R, 26 June 1954, vol.6, no.2, text
anon.

Exhibition, 'Drawings from Greek
Mythology and Heroic Saga', Leicester
Galleries, June 1954.

Wood engraver and illustrator, founder
of Gemini Press.

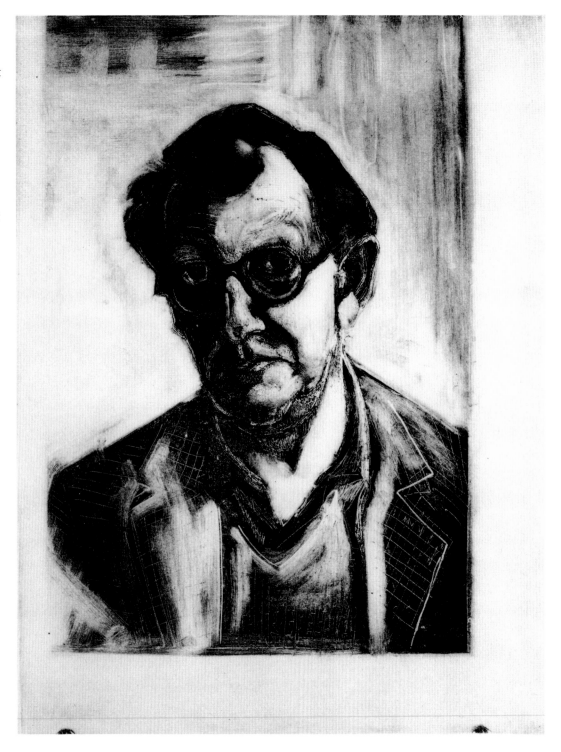

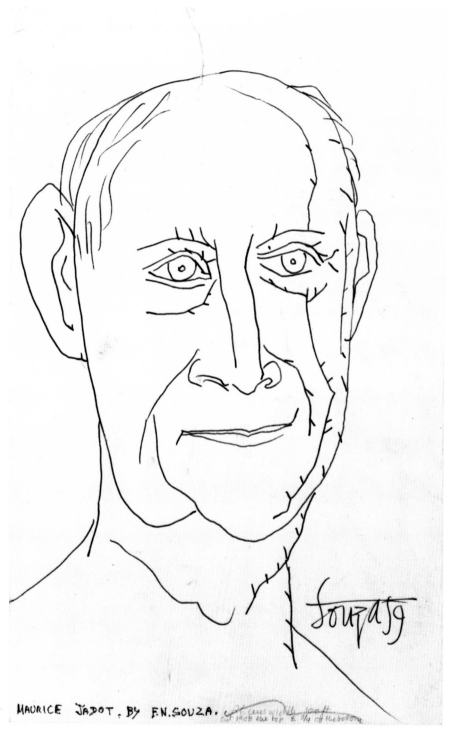

MAURICE JADOT. BY F.N.SOUZA.

Maurice Jadot 1893–1983

Portrait 1959 8214.42
by F.N. Souza b.1924

Ink on paper 330 × 204 (13 × 8)
Inscribed 'Souza 59' l.r. and 'MAURICE
JADOT BY F. N. SOUZA' bottom
AN & R, 29 August 1959, vol.11, no.16,
text by Denis Bowen

Exhibition, 'Paintings', Drian Gallery,
August–September 1959.

Abstract painter, and maker of reliefs in
plywood, born in Belgium.
Retrospective exhibition, National
Museum of Wales, Cardiff, April–May
1979.

Louis James b.1920

Self-Portrait 8214.43

Ink on paper 356 × 245 (14 × 9⅝)
Inscribed 'Louis James' b.r.
AN & R, 9 November 1957, vol.9,
no.21, text by Pierre Rouve

Exhibition, 'Paintings of Spain', Redfern
Gallery, October–November 1957.

Landscape and figure painter, born in
Adelaide, Australia, lived in Britain
1950–64, exhibited at Artists'
International Association.
Retrospective exhibition, Bonython-
Meadmore Gallery, Adelaide,
November 1986.

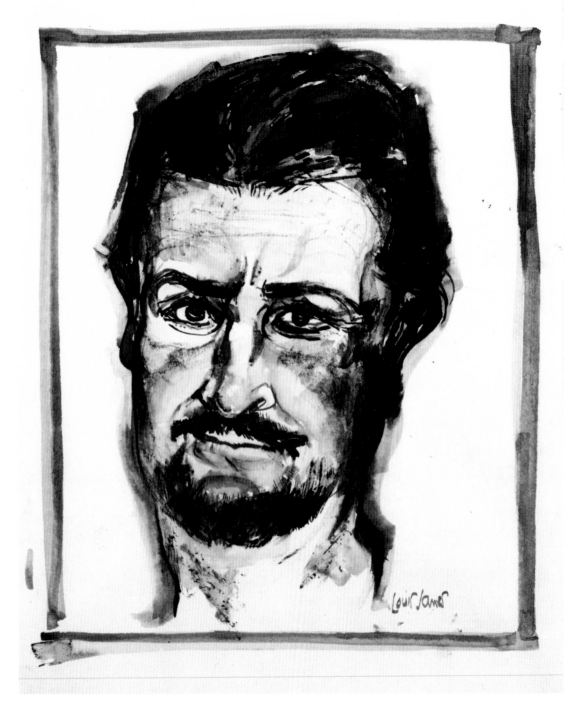

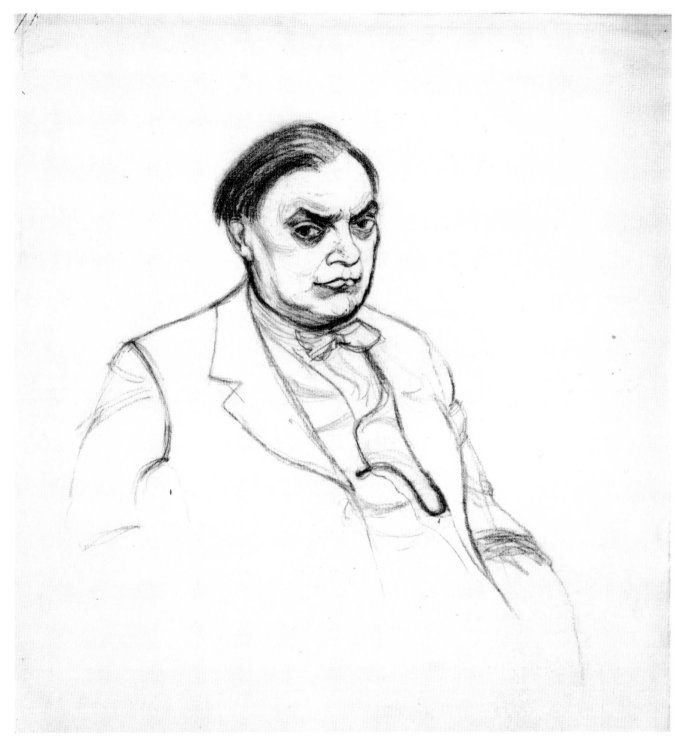

William Johnstone
1897–1981

Portrait [1953] 8214.44
by Morris Kestelman b.1905

Pencil and charcoal on paper
516 × 475 (20⅜ × 19⅛)
Not inscribed
AN & R, 7 March 1953, vol.5, no.3, text
by Max Bernd-Cohen

'Retrospective Exhibition of Paintings',
Lefevre Gallery, March–April 1953.

Landscape and abstract painter,
author, Principal of Camberwell School
of Arts and Crafts 1938, Central School
of Arts and Crafts 1946. Retrospective
exhibition, Hayward Gallery,
February–March 1981.

Karin Jonzen b.1914

Self-Portrait [1945] 8214.45

Ink and wash on paper 232 × 201
(9⅛ × 7⅞)
Not inscribed
AN & R, 17 December 1949, vol.1,
no.23, text by Karin Jonzen

Exhibition at Weekend Gallery,
December 1949.

Figure and portrait sculptor, chiefly in
terracotta, born in London of Swedish
parents.

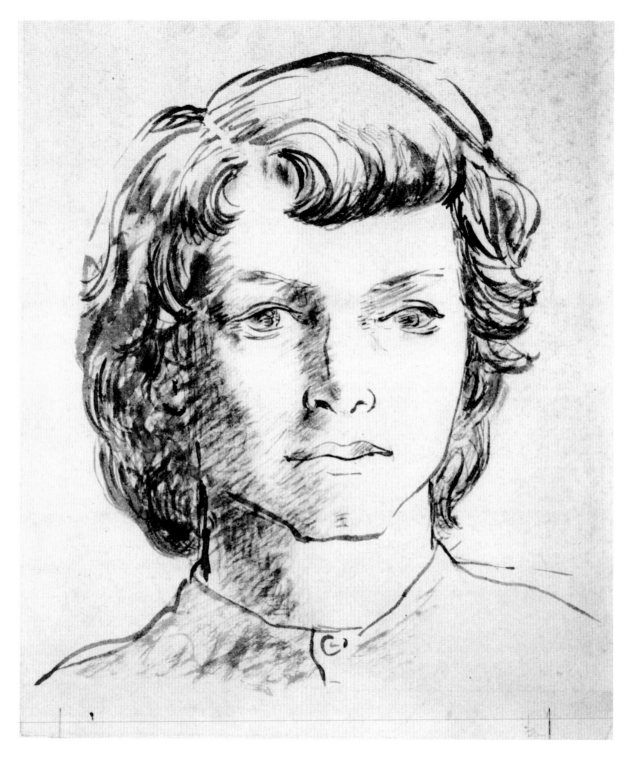

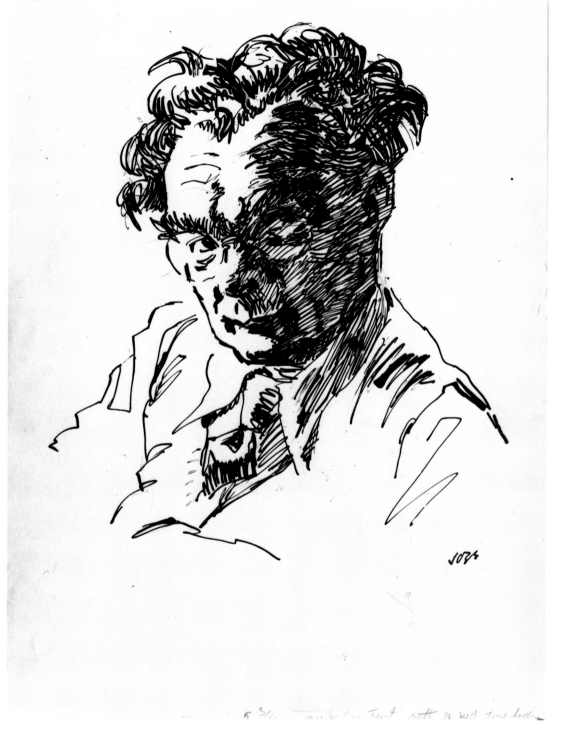

Joss

Self-Portrait 8214.46

Ink and gouache on paper 475 × 369
(18¾ × 14½)
Inscribed 'Joss' b.r.
AN & R, 27 January 1951, vol.2, no.26,
text anon.

F. Joss, exhibited sketches of India at
Leger Galleries, June 1954.

Michel Kikoine 1892–1968

Self-Portrait 8214.47

Ink and crayon on paper 290 × 233
($11\frac{3}{8} × 9\frac{1}{4}$)
Inscribed 'Kikoine par lui même' b.r.
AN & R, 5 March 1955, vol.7, no.3, text
by George Pillement

Exhibition, 'Paintings', Redfern Gallery,
March–April 1955.

Figure and landscape painter, born in
Lithuania, lived in Paris from 1913,
exhibited in London, 1955–63.

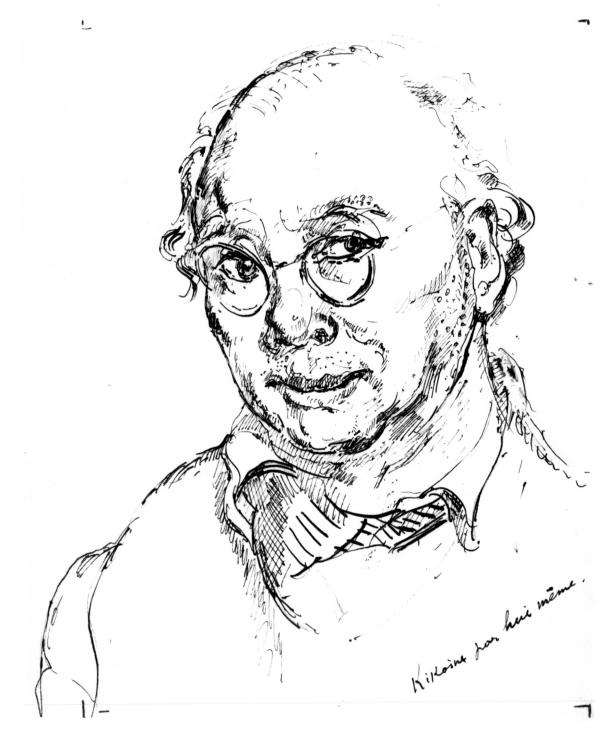

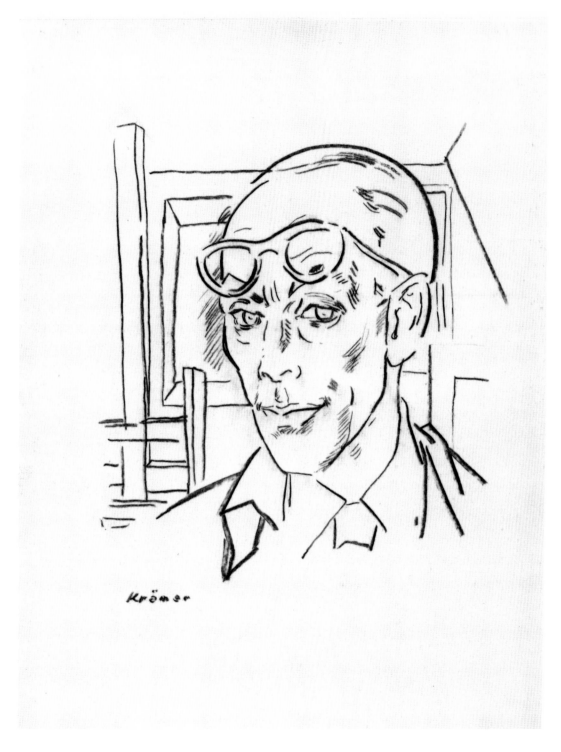

Fritz Kramer b.1905

Self-Portrait 8214.48

Charcoal on paper 500 × 702 (20 × 30)
Inscribed 'Kramer' b.l.
AN & R, 30 October 1954, vol.6, no.20,
text anon.

Exhibition at Leighton House, October–
November 1954.

Painter of landscapes and figures,
especially portraits of children, born in
Vienna, lecturer in Fine Art, University
of Durham.

Edwin La Dell 1914–1970

Self-Portrait [1955] 8214.49

Ink and gouache on paper 286 × 254
($11\frac{1}{4}$ × 10)
Not inscribed
AN & R, 26 November 1955, vol.7,
no.22, text anon.

Other versions, not published:

Self-Portrait 8214.50
Ink on paper 375 × 254 ($14\frac{3}{4}$ × 10)

Self-Portrait 8214.51
Ink and gouache on paper 381 × 254
(15 × 10)
Inscribed on reverse 'Edwin Ladell'

Self-Portrait 8214.52
Ink and gouache on paper 381 × 254
(15 × 10)

Exhibition at Zwemmer Gallery,
November–December 1955.

Lithographer, taught print-making,
Royal College of Art. Retrospective
exhibition, Blond Fine Art, September–
October 1985.

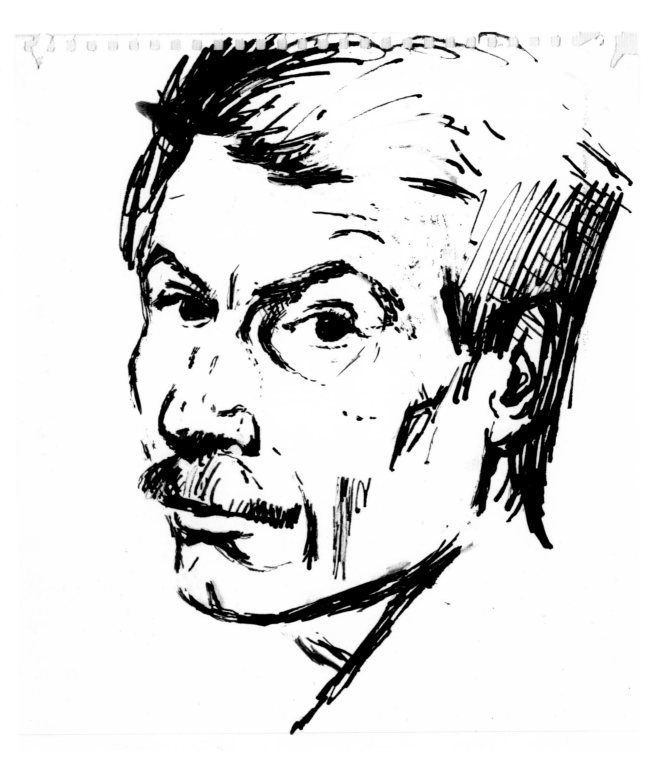

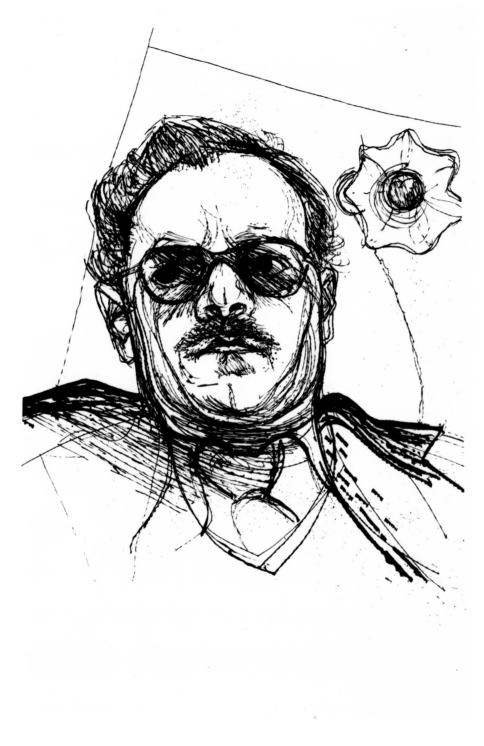

Nigel Lambourne b.1919

Self-Portrait 8214.53

Ink on paper 175×242 ($14\frac{3}{4} \times 9\frac{1}{2}$)
Not inscribed
AN & R, 2 October 1954, vol.6, no.18,
text anon.

Other versions, not published:

Self-Portrait 8214.54
Ink on paper 419×216 ($16\frac{1}{2} \times 8\frac{1}{2}$)

Self-Portrait 8214.55
Ink on paper 146×245 ($16 \times 9\frac{5}{8}$)
Inscribed 'June' on lapel

Exhibition, 'Recent Work', Zwemmer
Gallery, September–October 1954.

Print-maker and illustrator, studied
engraving, Royal College of Art. Taught
graphic art at St Martin's School of Art
from 1943 and Leicester Polytechnic
from 1971.

Louis Le Brocquy b.1916

Self-Portrait 1949 8214.56

Lithograph, artists proof aside from the
edition of 70, 260 × 197 ($10\frac{1}{4}$ × $7\frac{3}{4}$)
Printed in reverse '-49 Le Brocquy' b.l.
AN & R, 2 June 1951, vol.3, no.9, text
anon.

Exhibition, 'Drawings, Watercolours
and Tapestries by Louis Le Brocquy',
Gimpel Fils, June 1951.

Painter, particularly of heads, and
designer of tapestries and mosaics, born
in Dublin, lived in London from 1948
and in France from 1958. Retrospective
exhibition, Palais de Beaux Arts,
Charleroi, October–November 1982.

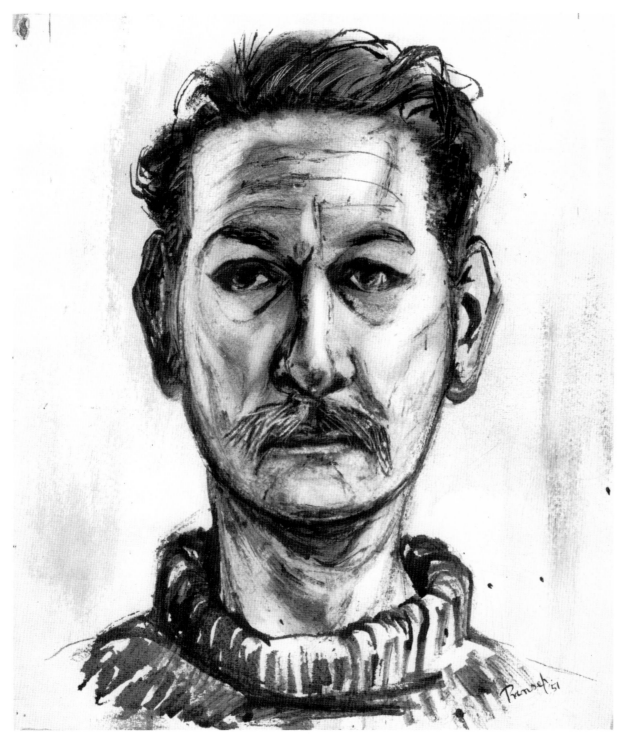

Anthony Levett-Prinsep
b.1908

Self-Portrait 1951 8214.57

Ink, pencil, watercolour and wax on
paper 400 × 343 ($15\frac{3}{4}$ × $13\frac{1}{2}$)
Inscribed 'Prinsep. '51' b.r.
A landscape on reverse, watercolour
and ink
AN & R, 24 March 1951, vol.3, no.4,
text anon.

Exhibition, 'Paintings and
Watercolours', Beaux Arts Gallery,
March 1951.

Painter of landscape in watercolour,
sculptor in wood and illustrator. Lived
in West Africa during war, now lives in
Denmark.

Mervyn Levy b.1915

Self-Portrait 8214.58

Charcoal on daler board 608 × 504
(24 × 20)
Inscribed 'Levy' on collar
AN & R, 28 May 1955, vol.7, no.9, text
anon.

Another version, not published:

Self-Portrait 1954 8214.59
Poster paint on paper, 524 × 347
($20\frac{7}{8} \times 13\frac{5}{8}$)
Inscribed 'Levy 54' r.

Graphic artist, author, critic,
broadcaster for radio and television,
associate editor, Art News & Review,
1956–61.

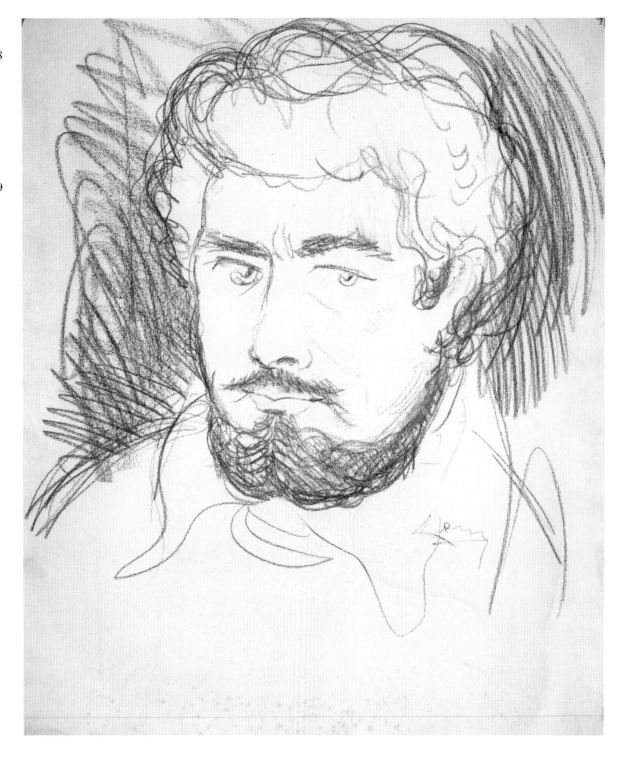

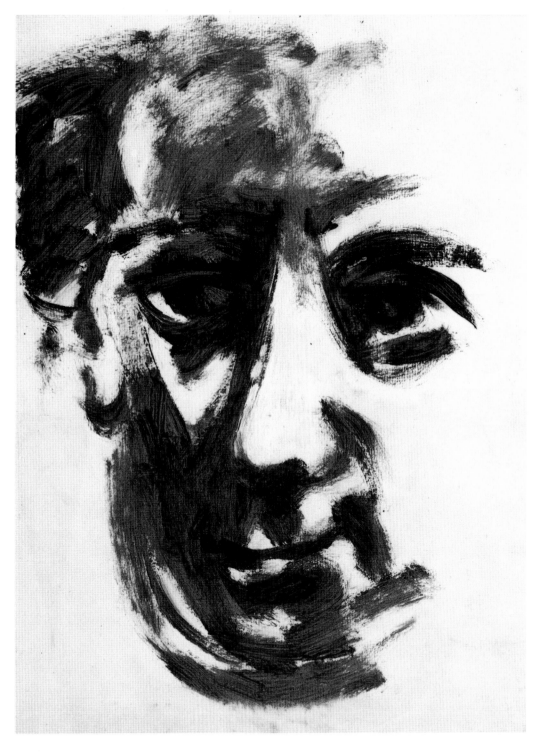

Jan Le Witt b.1907

Self-Portrait 8214.60

Oil on paper 324 × 242 ($12\frac{3}{4} \times 9\frac{1}{2}$)
Not inscribed
AN & R, 10 March 1951, vol.3, no.3,
text anon.

Exhibition, 'French Lithographs',
Hanover Gallery, March 1951.

Abstract painter, graphic artist, poet
and designer, born in Poland. Formed
the Le Witt-Him design partnership in
1933 and moved to London in 1937.
Retrospective exhibition, Zacheta
Palace, Museum of Modern Art,
Warsaw, October 1967.

Lippy Lipschitz 1903–1980

Self-Portrait 1948 8214.61

Ink on paper 271 × 204 (10⅝ × 8)
Inscribed 'Lippy London 1948' b.r.
Not published

Exhibitions Galerie Apollinaire,
April–May 1948; The Little Gallery,
London, June 1948.

Sculptor in wood and stone, born in
Russia, trained in Cape Town and in
Paris 1926–30 under Bourdelle,
returned to South Africa, 1933–47,
came to London for a short period, after
which returned to South Africa.

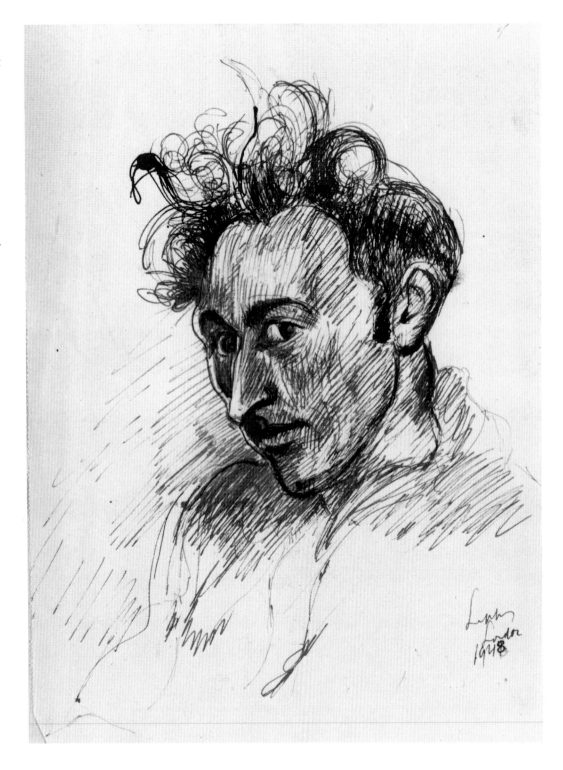

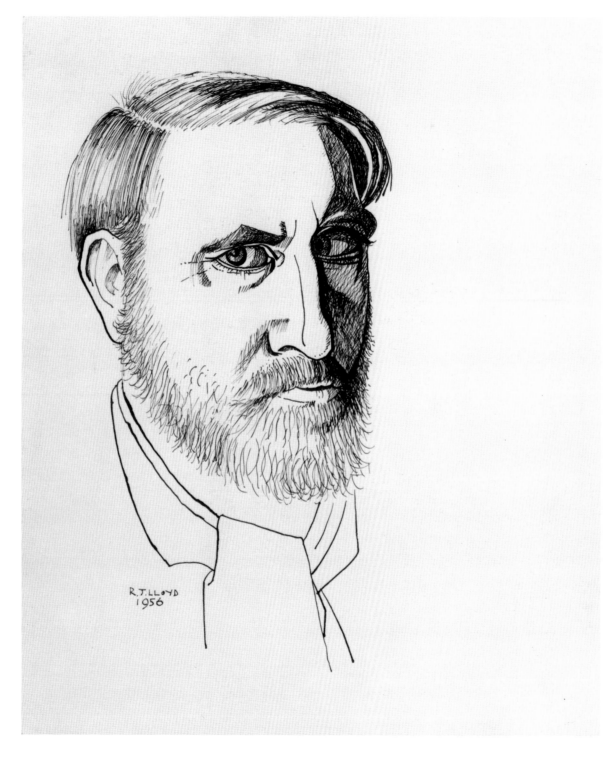

R.J. Lloyd b.1926

Self-Portrait 1956 8214.62

Ink on paper 305 × 254 (12 × 10)
Inscribed 'R.J. LLOYD 1956' b.l.
Not published

Landscape painter, particularly of
south-west Britain, stained-glass
designer.

F.E. McWilliam b.1909

Self-Portrait [1956] 8214.63

Charcoal on paper 296 × 233
(11⅝ × 9⅛)
Inscribed 'Please print reversed'
b.centre
AN & R, 18 February 1956, vol.8, no.2,
text by Albert Garrett

Exhibition, 'Sculpture', Hanover
Gallery, February–March 1956.

Figure sculptor in wood and bronze,
pre-war Surrealist, born in Ireland,
taught at Slade School 1947–68.
Retrospective exhibition, Ulster
Museum, Belfast, April–May 1981.
Exhibition at Tate Gallery, May–July
1989.

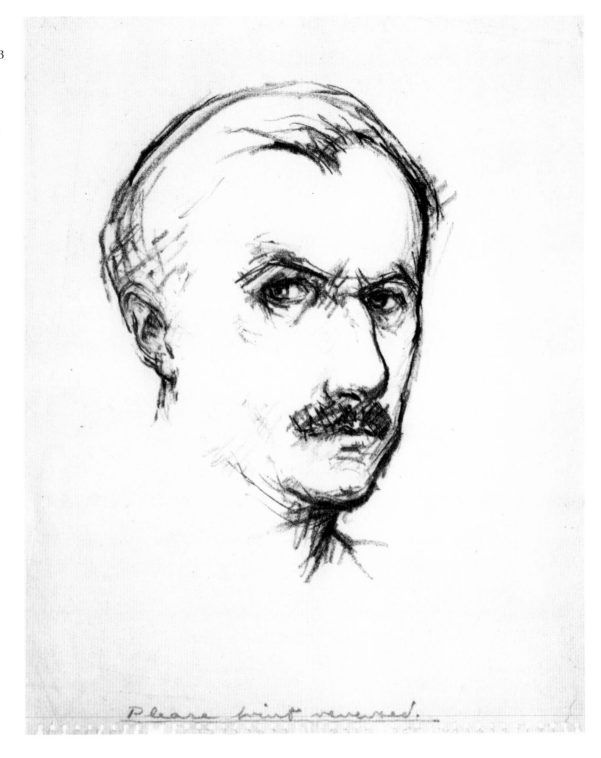

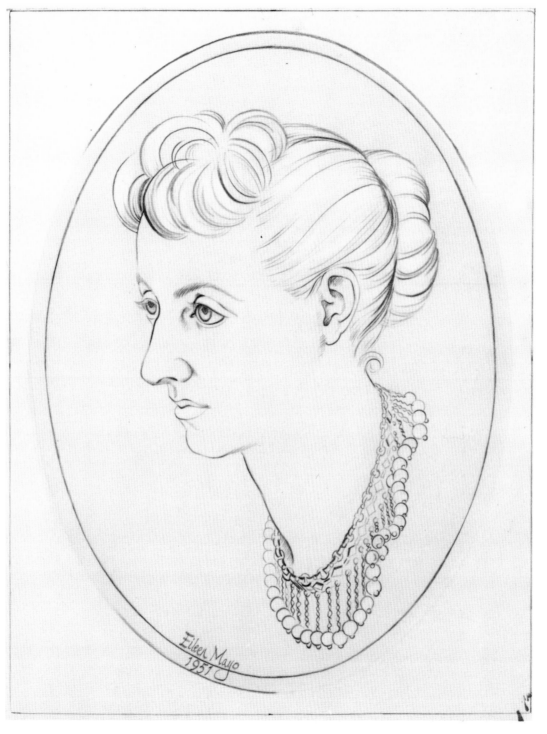

Eileen Mayo

Self-Portrait 1951 8214.64

Pencil on paper 343×263 ($13\frac{5}{8} \times 10\frac{1}{2}$)
Inscribed 'Eileen Mayo 1951' b.l.
AN & R, 11 August 1951, vol.3, no.14,
text anon.

Painter, illustrator and print-maker,
teacher at St Martin's School of Art,
wife of Richard Gainsborough (editor of
Art News & Review), lived in Australia
from late 1950s.

Bernard Meninsky 1891–1950

Self-Portrait 8214.65

Pencil on paper 386 × 281 (15¼ × 11)
Inscribed 'Meninsky' b.r.
AN & R, 12 February 1949, vol.1, no.1,
text anon.

Painter of nudes in landscape, war
artist, taught at Westminster School of
Art from 1920. Retrospective
exhibition, Museum of Modern Art,
Oxford, July–September 1981.

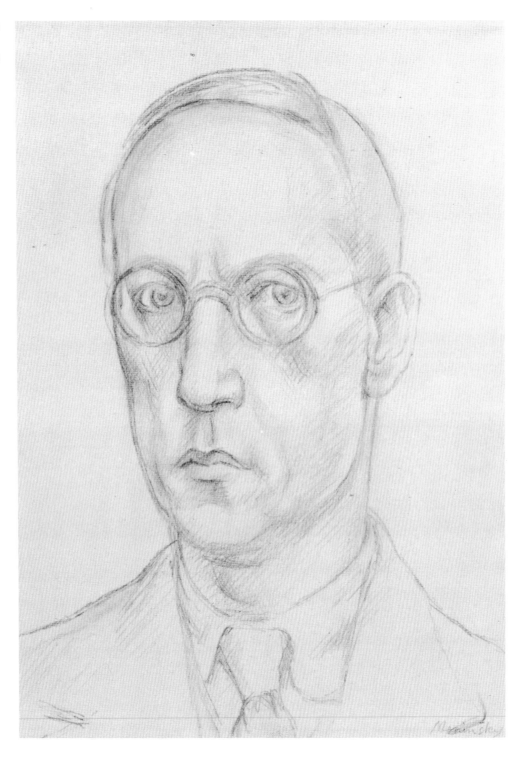

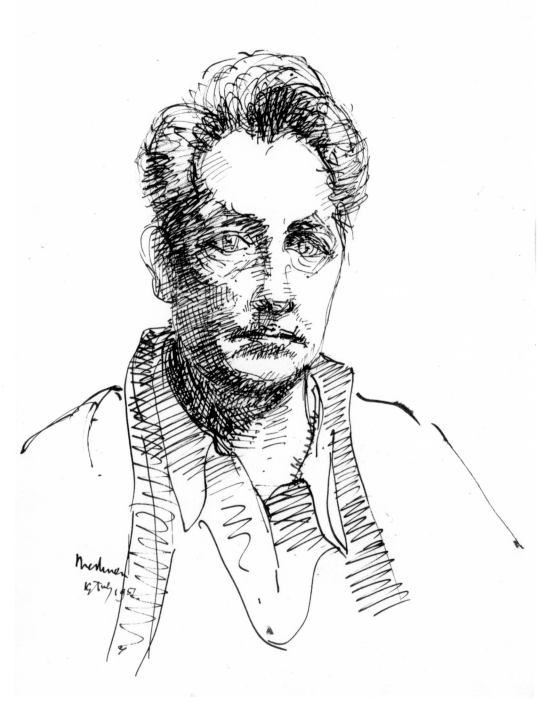

Lord Methuen 1886–1974

Self-Portrait 1951 8214.66

Ink on paper 368 × 276 (14½ × 10⅞)
Inscribed 'Methuen 19 July 1951' b.l.
and on reverse 'Self Portrait, send to
Ditchling Press, Hassocks, Sussex'
AN & R, 6 October 1951, vol.3, no.18,
text by Mary Sorrell

Exhibition, 'Recent pictures by Lord
Methuen', Leicester Galleries, October
1951.

Pupil of Sickert, painter of townscapes,
particularly of Bath, lived at Corsham
Court, Wiltshire.

The artist's nephew, the 6th Lord
Methuen, queries whether this is a self-
portrait as it looks more like the artist's
brother, Lawrence.

David Michie b.1928

Self-Portrait 8214.67

Charcoal on paper 495 × 330
(19½ × 13)
Not inscribed
AN & R, 22 January 1955, vol.6, no.26,
text by David Cleghorn Thomson

Exhibition 'Paintings by Nine Young
Artists', Parsons Gallery, January
1955.

Landscape, figure and flower painter,
teacher at Edinburgh College of Art
from 1961, Head of Drawing and
Painting from 1982.

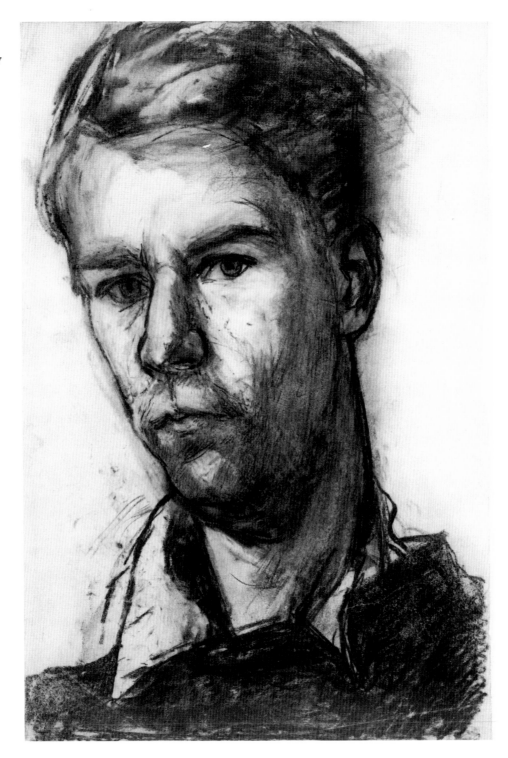

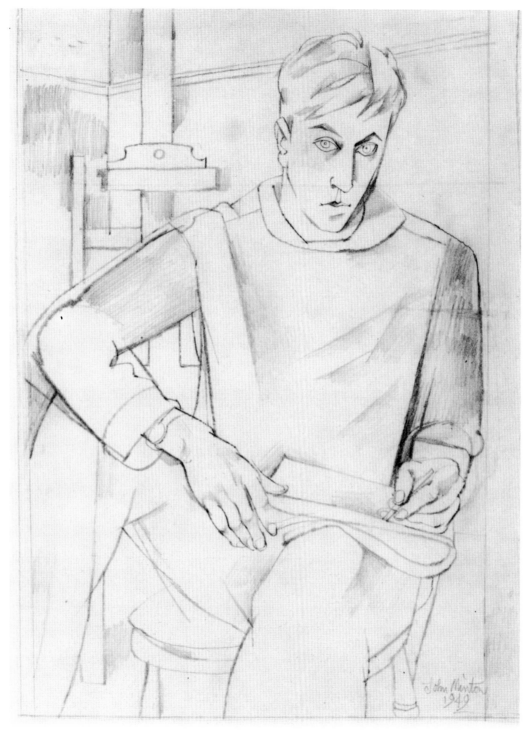

John Minton 1917–1957

Self-Portrait 1949 8214.68

Pencil on paper 315 × 233 (12⅜ × 9⅛)
Inscribed 'John Minton 1949' b.r.
AN & R, 9 April 1949, vol. 1, no. 5, text
anon.

Exhibition, 'New Paintings and
Watercolours', Lefevre Gallery,
February–March 1949.

Painter and illustrator, taught at Royal
College of Art from 1948, leading neo-
romantic artist. Retrospective
exhibitions, Reading Museum and Art
Gallery, November 1974 and Morley
Gallery, London, February–March
1979.

Colin Moss b.1914

Self-Portrait 8214.69

Ink on paper 254 × 200 (10 × 7$\frac{7}{8}$)
Inscribed 'Colin Moss' b.r.
AN & R, 18 August 1956, vol.8, no.15,
text by Mervyn Levy

Exhibition, 'Paintings', Prospect
Gallery, August 1956.

Landscape painter, Head of Painting,
School of Art, Ipswich. Retrospective
exhibition, Christchurch Mansion,
Ipswich, April–May 1981.

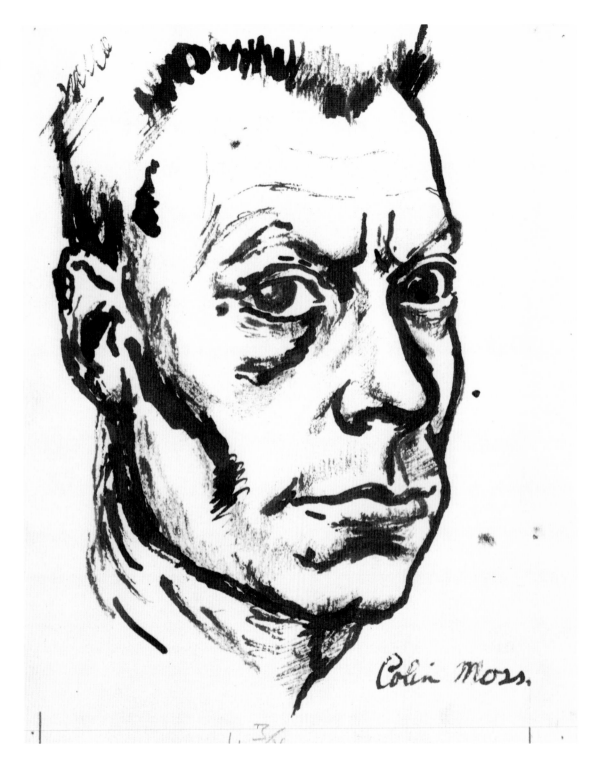

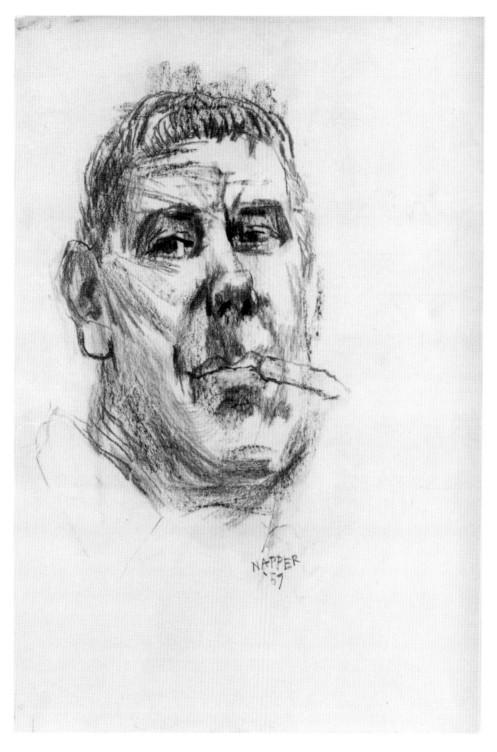

John Napper b.1916

Self-Portrait 1957 8214.70

Pastel on paper 650×435 ($25\frac{5}{8} \times 17\frac{1}{8}$)
Inscribed 'Napper '57' b.r.
AN & R, 11 May 1957, vol.9, no.8, text
by L.M.

Exhibition, 'Recent Paintings', Adams
Gallery, May 1957

Portrait painter, lived in Paris in 1950s.
Retrospective exhibition, Oldham Art
Gallery, July–September 1984.

John O'Connor b.1913

Self-Portrait 8214.71

Watercolour on paper 475 × 394
(19 × 15½)
Not inscribed
AN & R, 13 September 1950, vol.2,
no.17, text anon.

Another version, not published:

Self-Portrait 8214.72
Ink and watercolour on paper
403 × 478 (15⅞ × 18⅞)

Exhibition, Paul Alexander Gallery,
September 1950.

Painter and engraver, illustrator for
private presses. Retrospective
exhibiton, New Grafton Gallery, 1980.

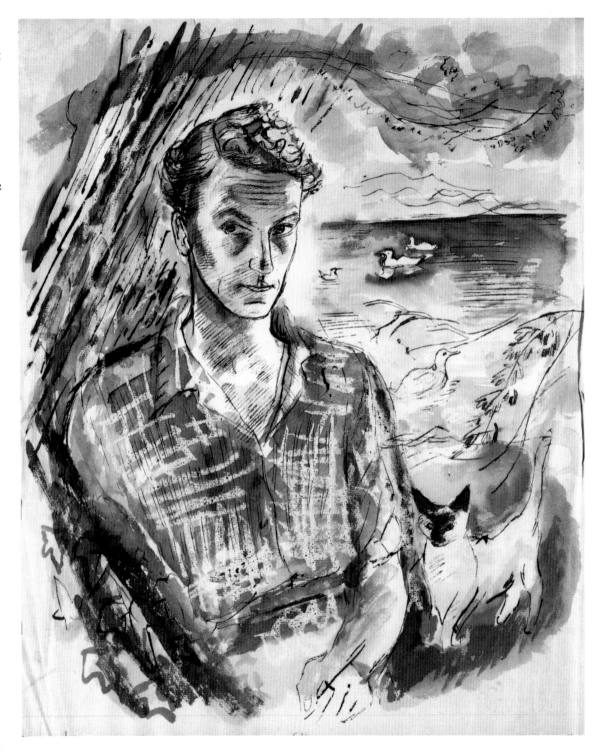

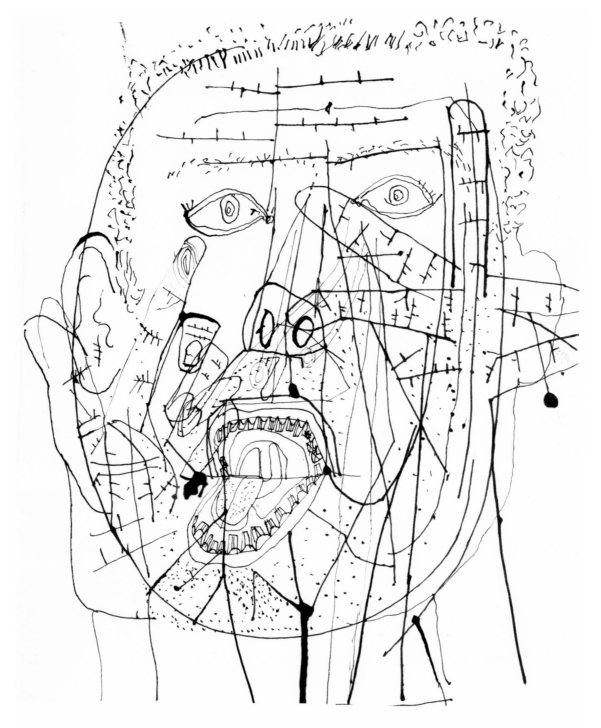

Sir Eduardo Paolozzi b.1924

Self-Portrait 8214.73

Ink on paper 257 × 220 (10⅛ × 8⅝)
Not inscribed
AN & R, 5 September 1953, vol.5,
no.16, text by Toni Del Renzio

Group exhibition, 'Parallel of Life and
Art', ICA, August 1953.

Sculptor and print-maker of popular,
scientific and abstract subjects.
Teacher, Central School of Arts and
Crafts 1950, St Martin's School of Art,
Sculpture 1955, Akademie der Bilden
den Kunst, Munich, Professor of
Sculpture, since 1981; Royal College of
Art, Tutor in Ceramics, since 1968.
Retrospective exhibition, 'Recurring
Themes', Royal Scottish Academy,
Edinburgh and foreign tour from 1984.

David Partridge b.1919

Self-Portrait 1957 8214.74

Ink on paper 355 × 252 ($14 × 9\frac{9}{10}$)
Inscribed 'David Partridge 1957' b.r.
AN & R, 17 August 1957, vol.9, no.15,
text by R.G.

Exhibition, 'Paintings and Drawings',
Rose and Crown, Fletchling, August
1957.

Landscape and abstract painter,
especially of nail configurations. Born
in the U.S., came to the U.K., moved to
Canada and took citizenship 1944.
Returned to U.K. permanently in 1962.

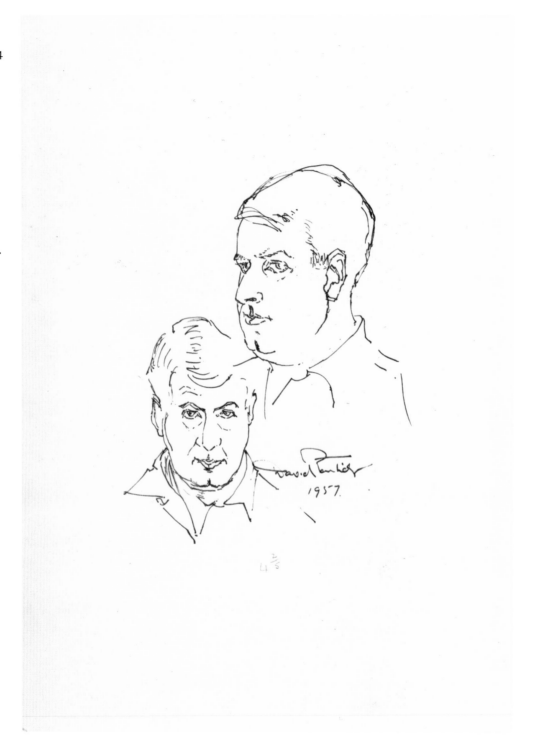

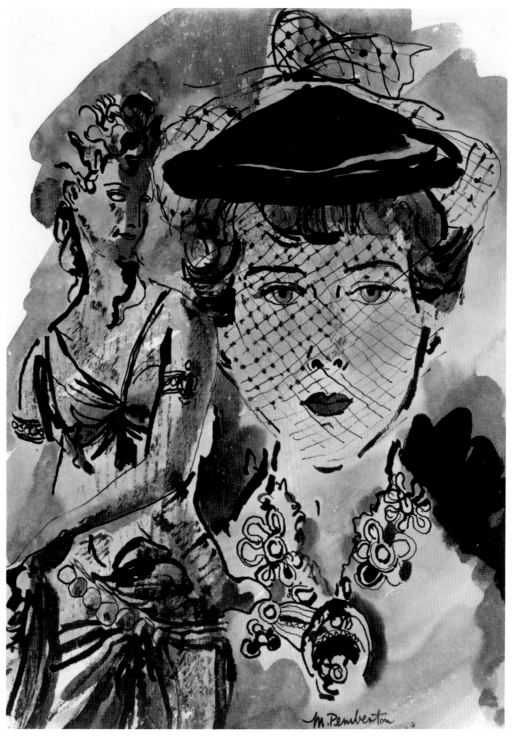

Muriel Pemberton b.1919

Self-Portrait 8214.75

Ink and watercolour on paper
330 × 238 (13 × 9¾)
Inscribed 'M. Pemberton' b.r.
AN & R, 7 April 1951, vol. 3, no. 5, text
anon.

Exhibition, 'First Exhibition of Pictures',
Leicester Galleries, March 1951.

Fashion artist, trained at Burslem and
Royal College of Art. Founder 1932,
Head of Fashion and Textile
Department, St Martin's School of Art,
until 1975. Exhibition, The Gallery,
Brighton Polytechnic, September–
October 1980.

David Peretz b.1906

Self-Portrait 8214.76

Ink, watercolour and pencil on paper
400 × 296 ($15\frac{3}{4}$ × $11\frac{5}{8}$)
Inscribed 'PERETZ' b.r.
AN & R, 4 January 1958, vol.9, no.25,
text anon.

Exhibition, 'Paintings', Crane Kalman
Gallery, January 1958.

Abstract painter, born in Bulgaria, lived
in Paris from 1947.

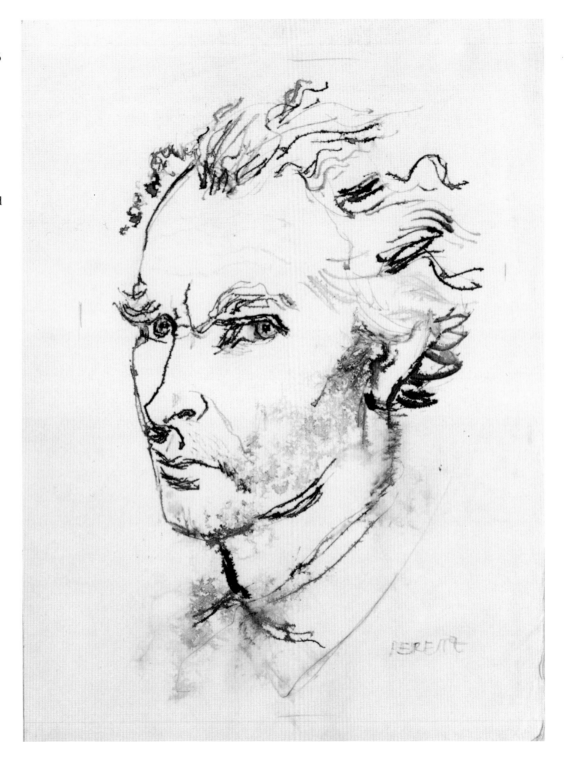

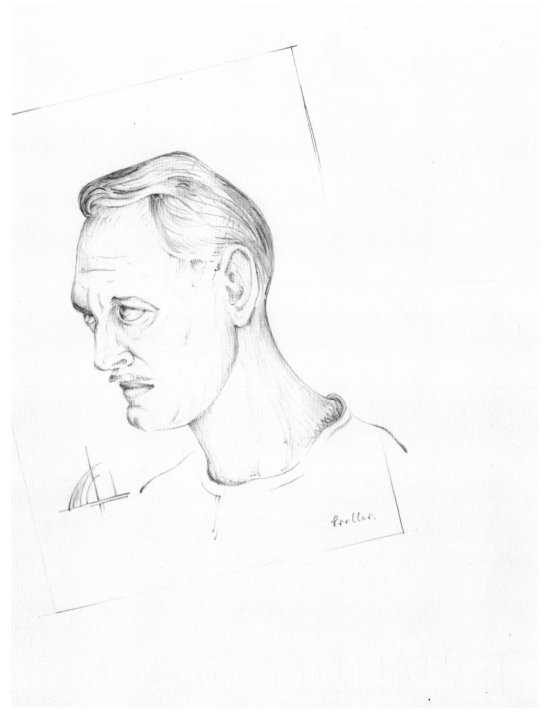

Preller

Self-Portrait 8214.77

Pencil on paper 232×181 ($9\frac{1}{8} \times 7\frac{1}{8}$)
Inscribed 'Preller' b.r.
Not published

Another version not published:

Self-Portrait 8214.78
Pencil on paper 234×324 ($9\frac{1}{8} \times 12\frac{3}{4}$)
Inscribed 'Preller', b.r.

Dod Procter 1891–1972

Self-Portrait 1956　　8214.79

Ink and wash on paper 297 × 212
($11\frac{3}{4} \times 8\frac{3}{8}$)
Inscribed 'Dod Procter. 1956. In the
Bay of Biscay'
Not published

Painter of portraits and figures, studied
at Newlyn and Paris, wife of Ernest
Procter, lived in Newlyn. Memorial
exhibition, Fine Arts Society,
September 1973.

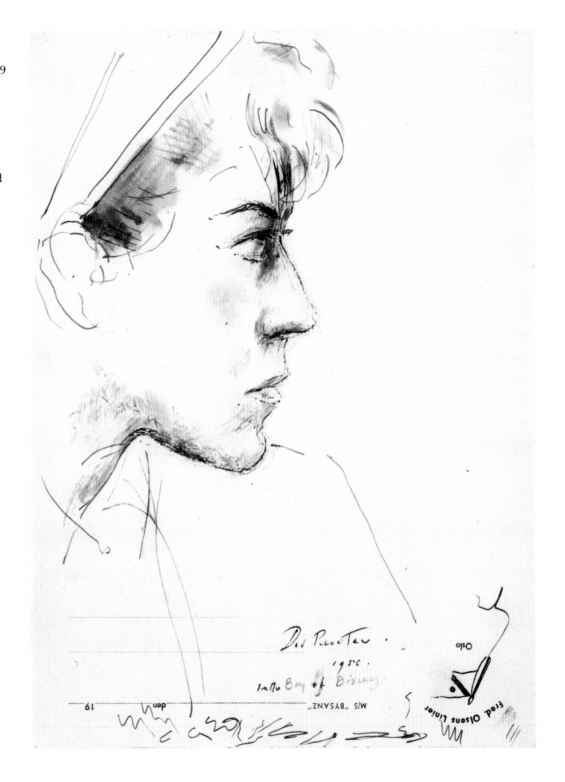

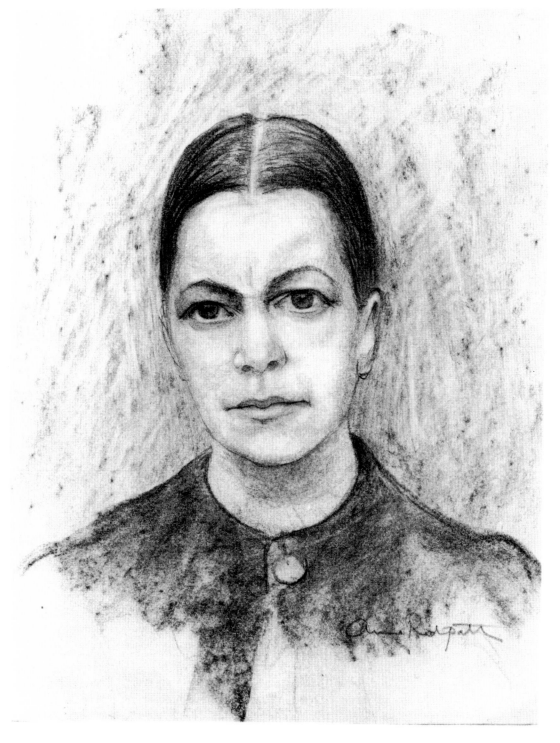

Anne Redpath 1895–1965

Self-Portrait 8214.80

Pencil on paper 340 × 257 (13⅜ × 10⅛)
Inscribed 'Anne Redpath' b.r.
AN & R, 22 March 1952, vol.4, no.4,
text by Mary Sorrell

Exhibition, 'Paintings', Lefevre Gallery,
November–December 1952.

Landscape, portrait and still-life
painter. Educated Edinburgh College of
Art, also in France and Italy. First
woman Academician at Royal Scottish
Academy. Retrospective exhibition,
Mercury Gallery, January 1981.

Alan Reynolds b.1926

Portrait 1956 8214.81
by Francis Sisley b.1921

Ink and watercolour on paper
235 × 152 (9¼ × 6)
Inscribed 'SISLEY 56' b.r.
AN & R, 3 March 1956, vol.8, no.3, text
by K.G. Sutton

Exhibition, 'The Four Seasons', Redfern
Gallery, March 1956.

Landscape and abstract painter.
Retrospective exhibition, Thomas
Agnew, July–August 1982.

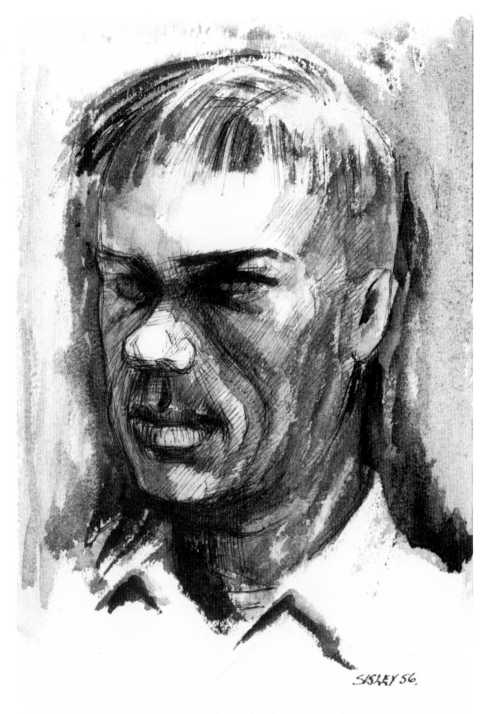

[84]

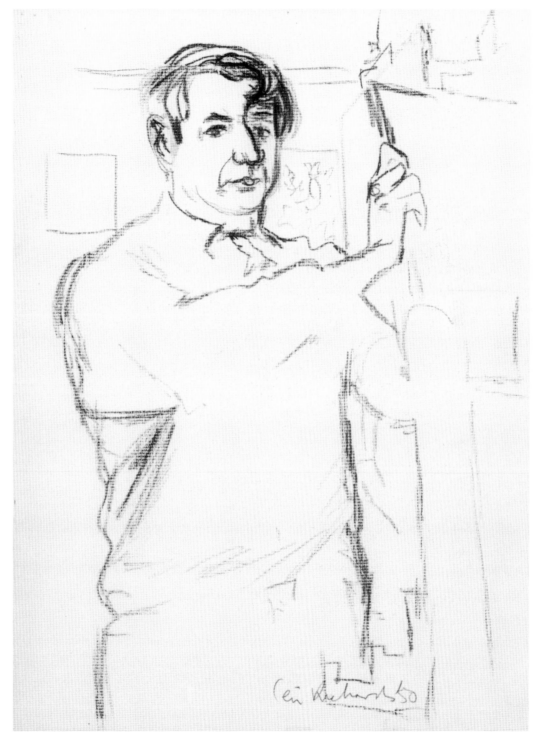

Ceri Richards 1903–1971

Self-Portrait 1950 8214.82

Crayon on paper 356 × 267 (14 × 10½)
Inscribed 'Ceri Richards '50' b.r.
AN & R, 29 July 1950, vol.2, no.13, text
by Mary Sorrell

Exhibition, 'Recent Paintings', Redfern
Gallery, June 1950.

Painter, draughtsman and print-maker
of musical and amorous subjects,
teacher at Chelsea College of Art.
Retrospective exhibition, Tate Gallery,
July–September 1981.

Frances Richards 1903–1985

Self-Portrait [1954] 8214.83

Ink on paper 381 × 277 (15 × 10⅞)
Inscribed 'F.R.' b.r.
AN & R, 13 November 1954, vol.6,
no.21, text anon.

Exhibition, 'New Works', Redfern
Gallery, November–December 1954.

Painter, graphic artist and illustrator,
teacher at Camberwell and Chelsea
Schools of Art, wife of Ceri Richards.

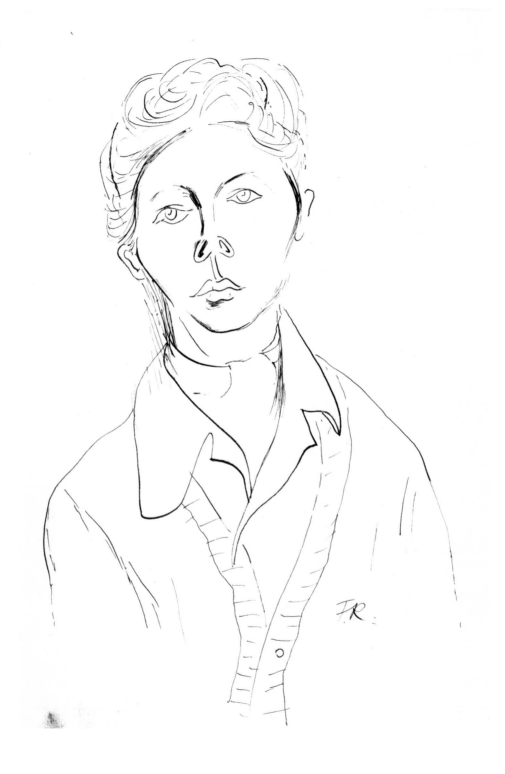

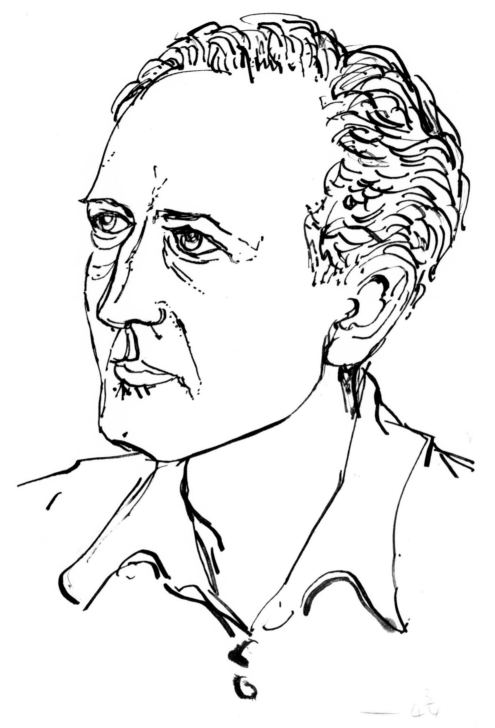

Dolf Rieser 1898–1983

Self-Portrait 8214.84

Ink on paper 257 × 173 (10⅛ × 6¾)
Not inscribed
AN & R, 14 April 1956, vol.8, no.6, text
by G.E. Speck

Another version, not published:

Self-Portrait 8214.85
Ink on paper 314 × 252 (12⅜ × 9⅞)
Inscribed 'Dolf Rieser' b.r.

Exhibition, 'Painting and Engravings',
Zwemmer Gallery, April–May 1956.

Engraver, born in South Africa and
trained in Paris. Member of Atelier 17
and the Anglo American Group.
Retrospective exhibition of engravings,
Christopher Drake Gallery, June 1974.

Brian Robb 1913–1979

Self-Portrait 8214.86

Ink on paper 353 × 248 (14 × 9¾)
Not inscribed
AN & R, 28 November 1953, vol.5,
no.22, text by H.S. Williamson

Other versions, not published:

Self-Portrait 8214.87
Ink on paper 353 × 248 (13⅞ × 9¾)
Inscribed on reverse 'ROBB'

Self-Portrait 8214.88
Ink on paper 353 × 248 (14 × 9¾)
On reverse a sketch of a woman and
cats inscribed 'Robb'

Landscape painter and illustrator,
teacher at Chelsea School of Art and
Royal College of Art.

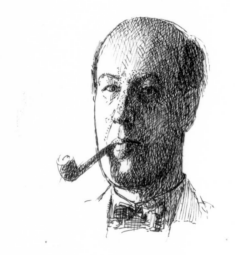

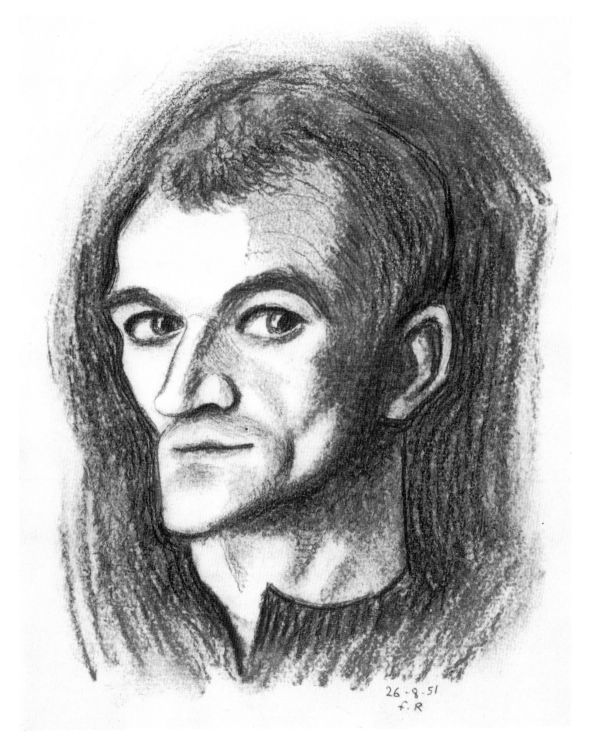

26-8-51
f. R

Dom Robert b.1907

Self-Portrait 1951 8214.89

Charcoal on paper 236 × 191 (9¼ × 7½)
Inscribed 'F.R. 26.8.51' b.r.
Not published
Another version published, AN & R, 15
December 1951, vol.3, no.23, not in
TGA 8214

Exhibition, Gimpel Fils, December
1951.

Painter of illuminations and
watercolours, maker of tapestries, born
in France, entered the Benedictine
Order in 1930.

William Roberts 1895–1980

Self-Portrait [1949] 8214.90

Red chalk on paper 318 × 241
(12½ × 9½)
Inscribed 'Roberts' below lapel and b.l.'
reproduc not to cut drawin
. . . . W.R.
AN & R, 5 November 1949, vol. 1,
no. 20, text by William Roberts

Exhibition, 'New drawings, satirical
and otherwise', Leicester Galleries,
November 1949.

Figure painter and draughtsman,
Vorticist. Retrospective exhibition, Tate
Gallery, October–November 1965.

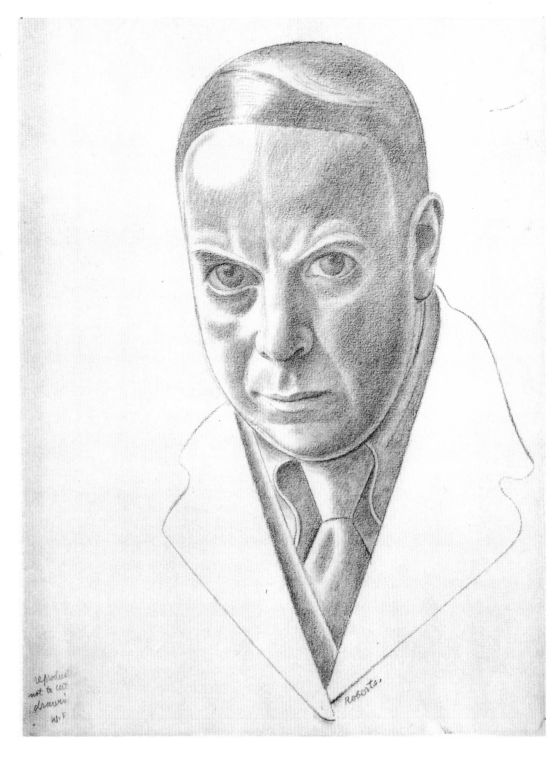

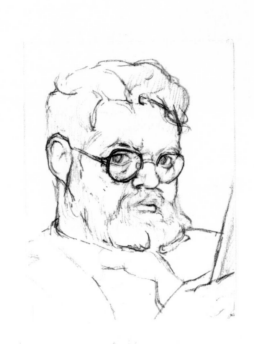

Claude Rogers 1907–1979

Self-Portrait 8214.91

Pencil on paper 146 × 114 (5¾ × 4½)
Not inscribed
AN & R, 16 June 1951, vol.3, no.10,
text anon.

Prizewinner, '50 Paintings for 51', Arts
Council's 'Festival of Britain'
competition.

Landscape and figure painter, teacher
at Euston Road School 1937–9.
Professor Fine Arts, Reading University,
1963–1972. Retrospective exhibition,
Whitechapel Art Gallery, April 1973.

Wall: maximum 9" width

Michael Rothenstein b.1908

Self-Portrait 1950 8214.92

Collage, pencil, monotype and pastel on
paper 440 × 330 (17⅜ × 13)
Inscribed 'Michael Rothenstein '50',
b.c.
AN & R, 13 January 1951, vol.2, no.25,
text by Bryan Robertson

Group exhibition at Redfern Gallery,
February 1951.

Painter and print-maker, especially of
large hand-coloured woodcuts, of
figurative and abstract subjects.
Exhibition, 'Works on Paper', The
Minories, Colchester 1981.

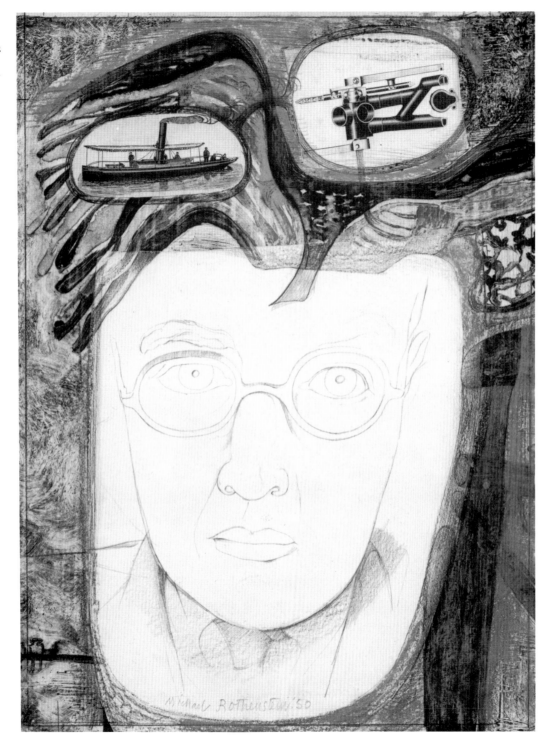

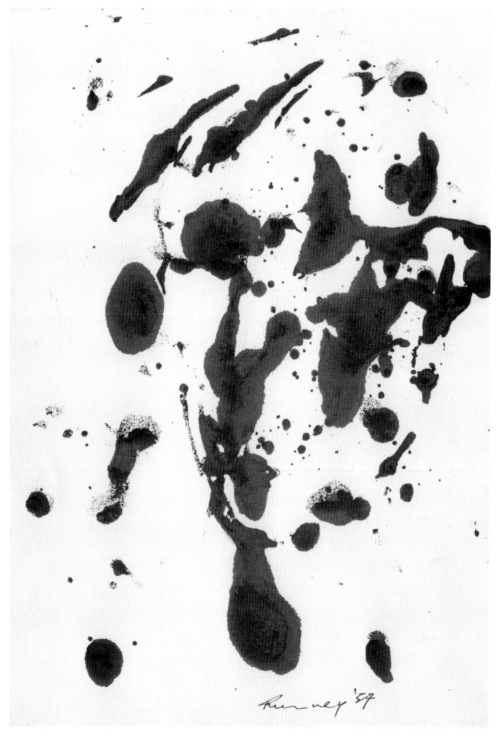

Ralph Rumney b.1934

Self-Portrait 1957 8214.93

Monoprint 252 × 178 (9⅞ × 7)
Inscribed 'Rumney '57' b.c.
AN & R, 22 June 1957, vol.9, no.11,
text by R.G.

Group exhibition, 'New Paintings',
Redfern Gallery, June–July 1957.

Abstract painter, worked in Paris
1951–55, exhibited at New Vision
Centre.

Zdzislaw Ruszkowski b.1907

Self-Portrait 8214.94

Aquatint 260 × 200 ($10\frac{1}{4}$ × $7\frac{7}{8}$)
Inscribed 'Ruszkowski' b.r.
AN & R, 26 January 1952, vol.3, no.26,
text anon.

Group exhibition, 'Recent Paintings',
Roland, Browse & Delbanco, January–
March 1952.

Semi-abstract landscape and figurative
painter and print-maker, born in
Poland, living in Britain since 1939.
Retrospective exhibition, Gillian Jason
Gallery, October 1986.

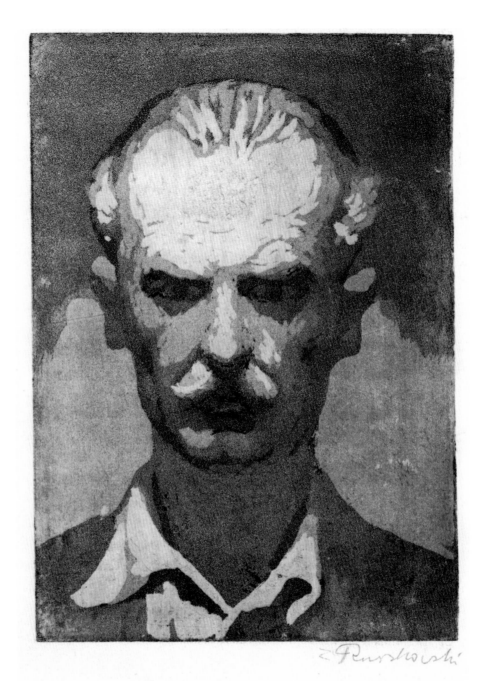

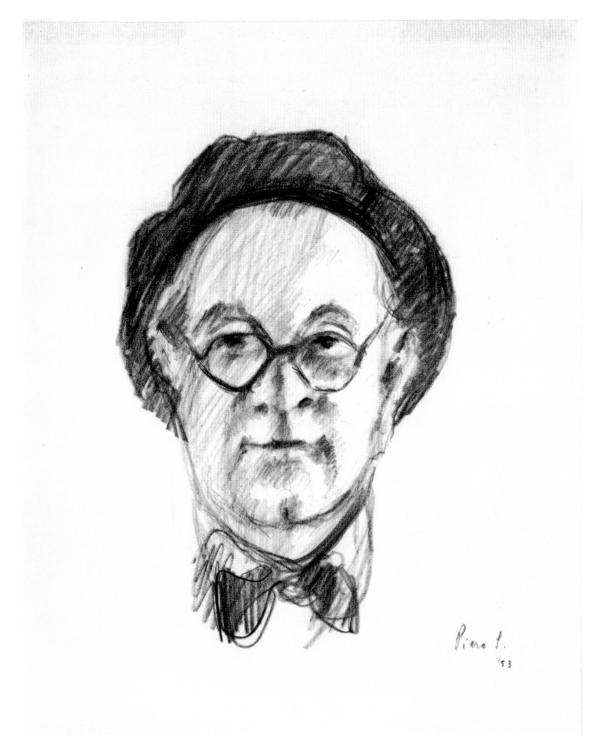

Piero Sansalvadore

1892–1953

Self-Portrait 1953 8214.95

Pencil on paper 292 × 226 ($11\frac{1}{2} × 8\frac{7}{8}$)
Inscribed 'Piero S. '53' b.r.
AN & R, 30 May 1953, vol.5, no.9, text
by Pierre Rouve

Exhibition, 'Paintings', Parsons Gallery,
May–June 1953.

Landscape and cityscape painter,
particularly of views of London, born in
Turin, came to Britain 1931.

Frederick Schaeffer b.1932

Self-Portrait 8214.96

Ink on paper 245 × 226 ($9\frac{5}{8}$ × $8\frac{7}{8}$)
Inscribed 'Schaeffer' b.r.
AN & R, October 1956, vol.8, no.20,
text by Mary Sorrell

Exhibition, 'Recent Paintings', Arthur
Jeffress Pictures, October 1956.

Abstract and religious painter, born in
America, pupil at Slade School 1952.

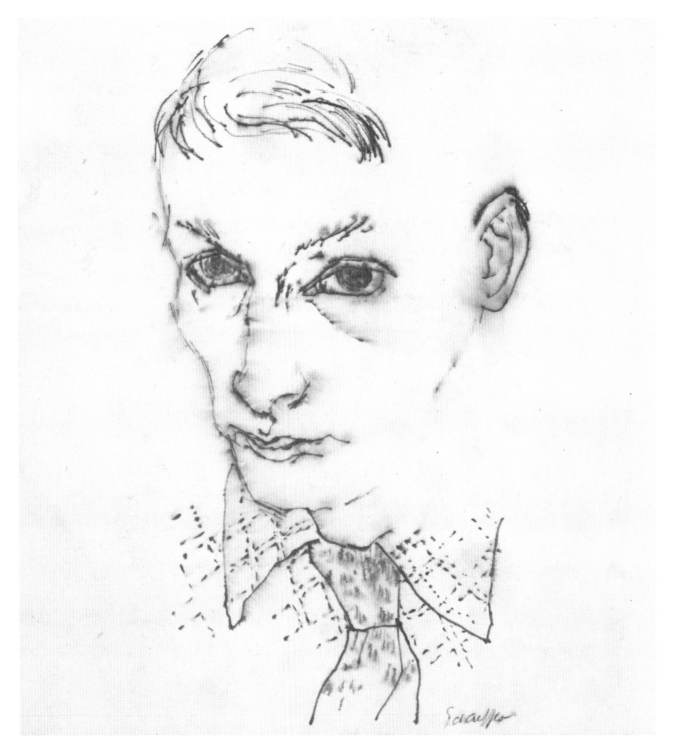

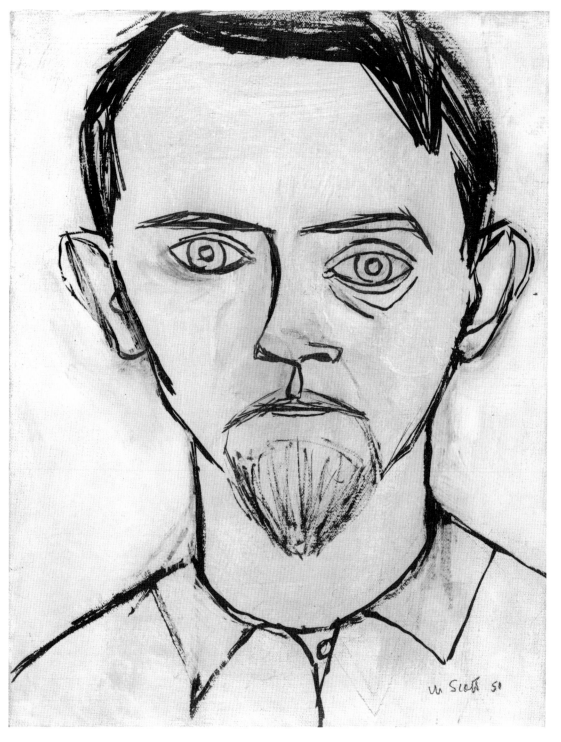

William Scott b.1913

Self-Portrait 1950 8214.97

Oil on canvas 280 × 220 (11 × 8⅝)
Inscribed 'W. Scott 50', b.r.
AN & R, 10 February 1951, vol. 3, no. 1,
text anon.

Exhibition, 'Recent Paintings by
William Scott', Leicester Galleries,
February 1951.

Painter of abstracted still life.
Retrospective exhibition, Ulster
Museum, Belfast, June–August 1986.

Ronald Searle b.1920

Self-Portrait 1949 8214.98

Ink on paper 347 × 270 (13⅝ × 10⅝)
Inscribed 'Ronald Searle 1949' b.r.
AN & R, 3 July 1950, vol.2, no.9, text
anon.

Exhibition, 'Drawings of Paris',
Leicester Galleries, September 1950.

Caricaturist, illustrator and
draughtsman, creator of schoolgirls of
St Trinians. Retrospective exhibition,
Bibliothèque Nationale, Paris, January–
March 1973.

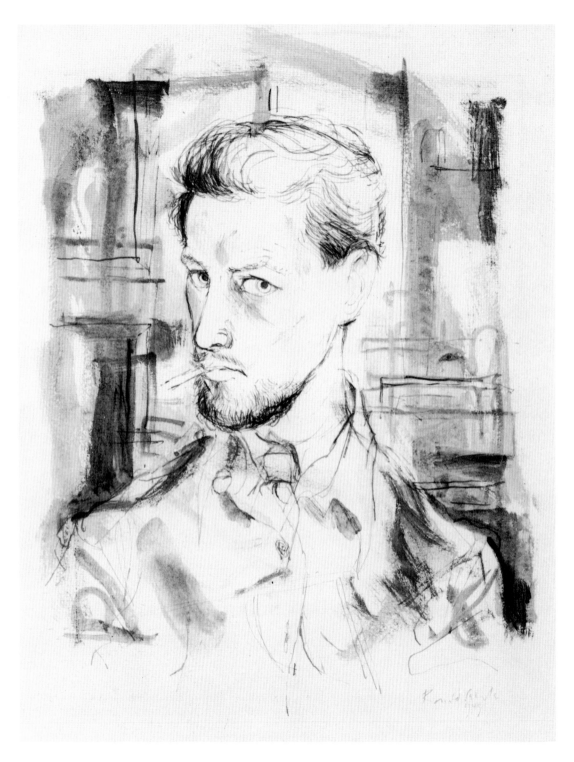

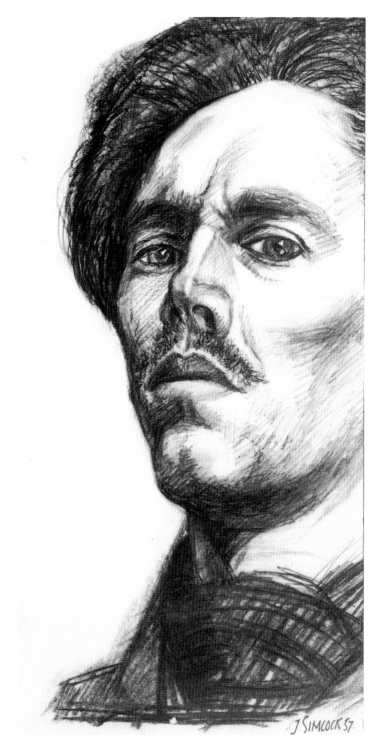

Jack Simcock b.1929

Self-Portrait 1957 8214.99

Pencil, charcoal and gouache on paper
$327 \times 150 \ (12\frac{7}{8} \times 5\frac{7}{8})$
Inscribed 'J. SIMCOCK 57' b.r.
AN & R, 6 July 1957, vol.9, no.12, text
by Reginald Haggar

Exhibition, Piccadilly Gallery, July
1957.

Painter of intense and detailed
landscapes, mostly of his home village
of Mow Cop, Cheshire. Trained at
Burslem School of Art.

Rowland Suddaby 1912–1972

Self-Portrait 8214.100

Ink on paper 280 × 250 ($11 × 9\frac{7}{8}$)
Inscribed on reverse 'Self Portrait,
ROWLAND SUDDABY, BROOKSIDE, CRABBE
LAND, GT CORNARD, SUDBURY, SUFFOLK'
AN & R, 31 December 1949, vol. 1,
no. 24, text anon.

Exhibition, Redfern Gallery, January
1950.

Landscape painter in oils and
watercolour. Retrospective exhibition,
Gainsborough's House, Sudbury,
December 1984–February 1985.

Philip Sutton b.1928

Self-Portrait 8214.101

Linocut 356 × 254 (14 × 10)
Inscribed 'P. Sutton' b.l.
AN & R, 19 January 1957, vol.8, no.26,
text by K.S.

Group exhibition, 'Six Young Artists',
Roland, Browse and Delbanco, January
1957.

Painter and print-maker of figures,
landscapes and interiors.

Hans Tisdall b.1910

Self-Portrait 8214.102

Gouache on paper 220 × 150 ($8\frac{5}{8} \times 5\frac{7}{8}$)
Not inscribed
AN & R, 26 August 1950, vol.2, no.15,
text anon.

Painter, designer of murals and
tapestries, illustrator, born in Munich,
settled in London 1930, teacher at
Central School of Arts and Crafts.

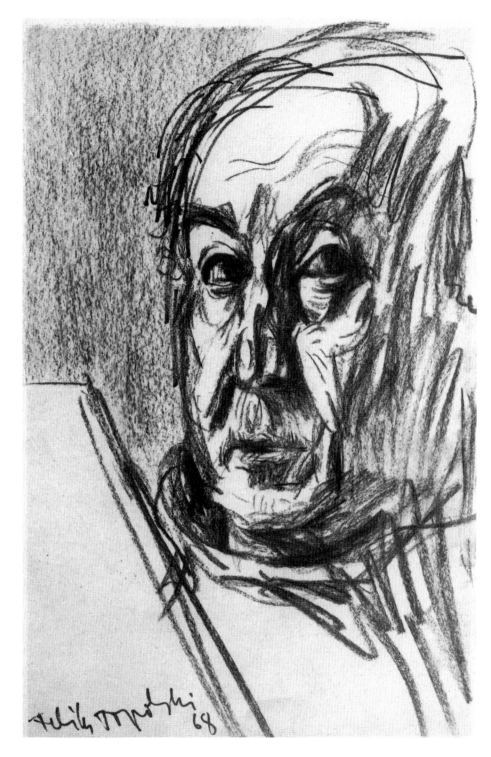

Feliks Topolski b.1907

Self-Portrait 1968 8214.103

Charcoal on paper 455 × 300
($17\frac{7}{8} × 11\frac{3}{4}$)
Inscribed 'Feliks Topolski 68' b.l.
AN & R, 17 February 1968, vol.20,
no.3, text anon.

Exhibition, 'Drawings', Grosvenor
Gallery, February–March 1968.

Portrait 8214.104
by Janina Konarska
Ink and pencil on paper 254 × 318
($10 × 12\frac{1}{2}$)
Inscribed 'J. Konarska', b.r.
Not published
Another version published, AN & R, 21
April 1951, vol.3, no.6, not in TGA
8214

Portrait painter, stage designer,
illustrator and author, born in Poland,
moved to London in 1935. Permanent
private exhibition under Hungerford
Bridge.

William Townsend

1907–1973

Self-Portrait 8214.105

Ink on paper 266 × 225 ($10\frac{1}{2} \times 8\frac{7}{8}$)
Inscribed 'Townsend' b.r.
AN & R, 21 October 1950, vol.2, no.19,
text anon.

Another version, not published:

Self-Portrait 8214.106
Pencil on paper 175 × 143 ($6\frac{7}{8} \times 5\frac{5}{8}$)
Inscribed 'Townsend' b.r.

Landscape painter, associated with
Euston Road School, taught at Slade
School from 1949, extracts from
'Journals' published by Tate Gallery
1976. Retrospective exhibition, Royal
West of England Academy, Bristol,
April–May 1978.

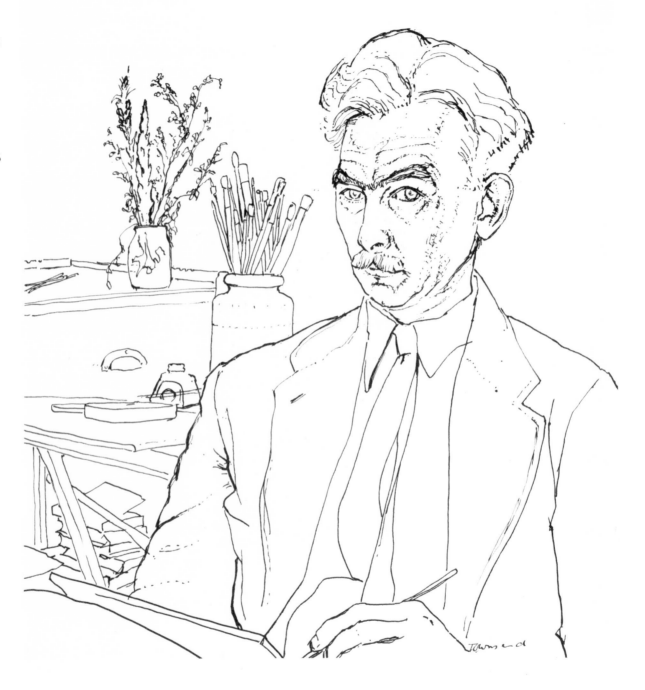

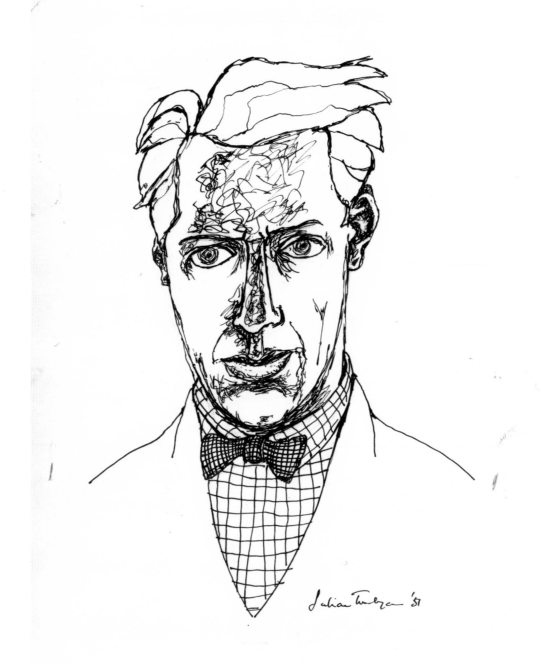

Julian Trevelyan 1910–1988

Self-Portrait 1951 8214.107

Ink and gouache on paper 405 × 266
(16 × 11⅝)
AN & R, 12 January 1952, vol.3, no.25,
text anon.

Exhibition, 'Recent Paintings by Julian
Trevelyan', Redfern Gallery, January
1952.

Painter and etcher, pre-war Surrealist,
teacher at Royal College and Chelsea
School of Art. Retrospective exhibition,
Watermans Arts Centre, January–
March 1986.

Tseng Yu b.1923

Self-Portrait [1955] 8214.108

Ink on paper 358 × 248 (3½ × 9¾)
Inscribed on reverse 'Self Portrait by
Tseng Yu'
AN & R, 3 September 1955, vol.7,
no.16, text by William Townsend.

Exhibition at Arthur Jeffress (Pictures),
September 1955.

Born in Shanghai, came to Europe
1952, studied at Slade School of Art
from 1953.

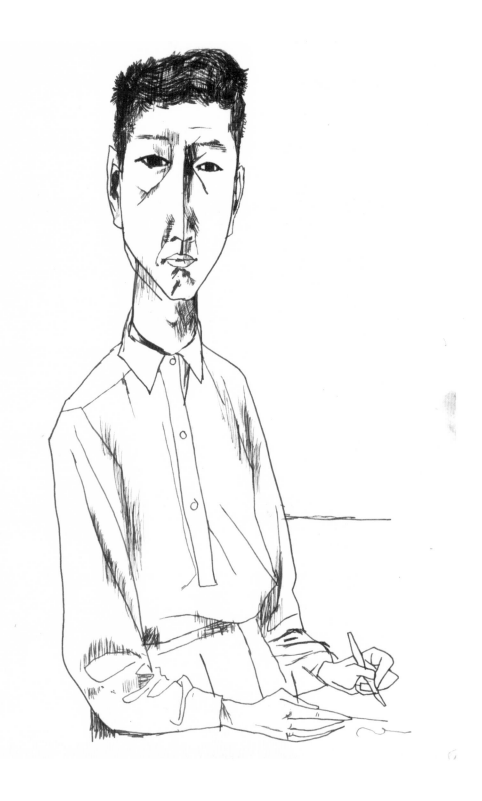

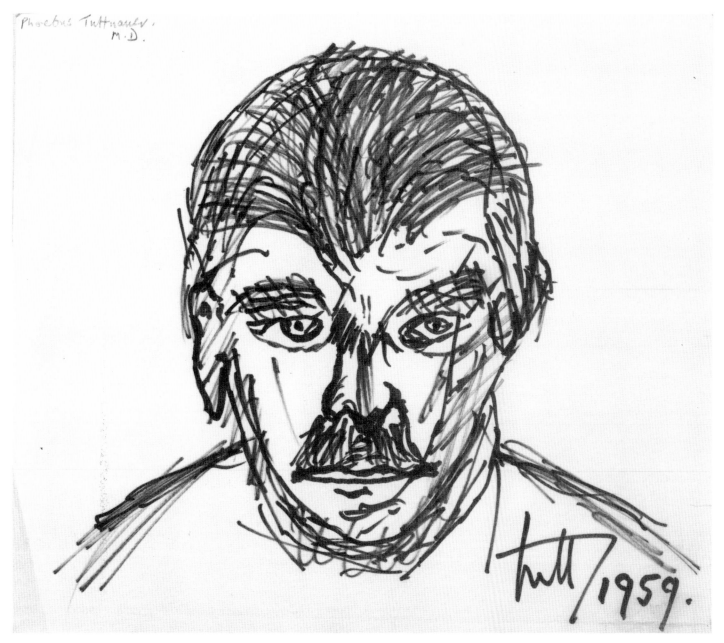

Phoebus Tuttnauer.
M.D.

tutt 1959.

Phoebus Tuttnauer b.1890

Self-Portrait 1959 8214.109

Pen on paper 216 × 254 (8 × 10)
Inscribed 'Phoebus Tuttnauer M.D.' b.r.
and 'tutt 1959' b.r.
AN & R, 28 March 1959, vol.11, no.5,
text by Mervyn Levy

Exhibition, 'Paintings', Ben Uri Gallery,
April 1959.

Born in Austria, plastic surgeon, came
to Britain 1938, first began to paint in
1955 in primitive style.

Edgard Tytgat 1879–1957

Self-Portrait 1927 8214.110

Woodcut 182 × 134 (7⅛ × 5¼)
Inscribed 'Edgard Tytgat 1927' b.r. and
below 'Woodcut, Gravure sur bois, Self
Portrait from 1927 Edgard Tytgat' b.l.
AN & R, 16 October 1954, vol.6, no.19,
text anon.

Exhibition, 'First Exhibition in
England', Arcade Gallery, October
1954.

Illustrator, print-maker, painter of
allegorical watercolours, born in
Brussels. Retrospective exhibition,
Musée Provisoire d'Art Moderne,
Brussels, January–March 1974.

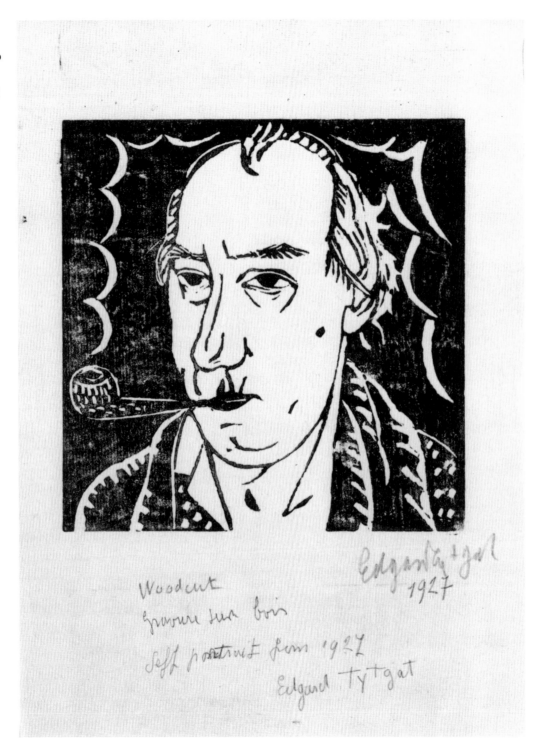

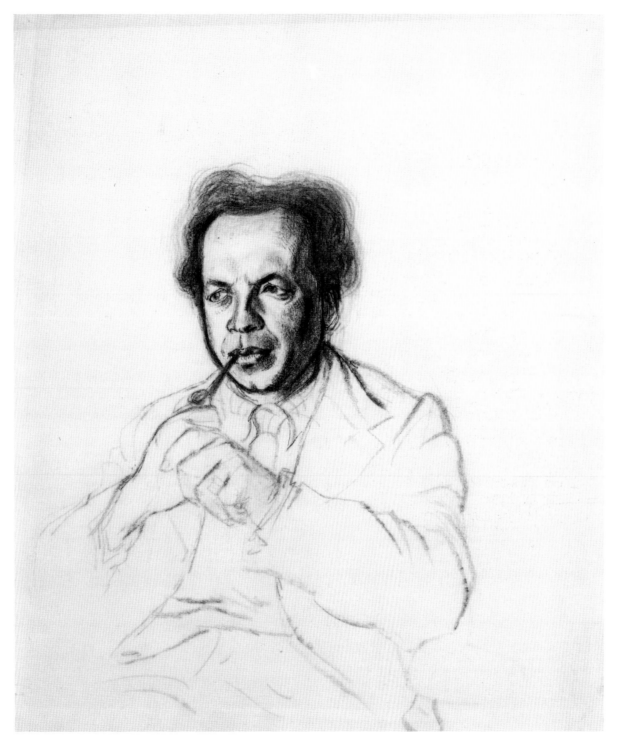

Fred Uhlman 1901–1985

Portrait [1949] 8214.111
by Morris Kestelman b.1905

Ink, charcoal and red chalk on paper
557 × 475 (22 × 18⅞)
Not inscribed
AN & R, 13 August 1949, vol.1, no.14,
text by Michael Rothenstein

Painter, born Stuttgart, moved to Paris
1933, lived in England from 1936,
member of London Group since 1943.
Retrospective exhibition, Martiswood
Gallery, Great Bardfield, May–June
1980.

Keith Vaughan 1912–1977

Self-Portrait 1950 8214.112

Pencil on paper 292 × 222 (11½ × 8¾)
Inscribed 'Keith Vaughan March 1950'
b.r.
AN & R, 8 April 1950, vol.2, no.5, text
anon.

Exhibition, 'Drawings for Rimbaud's *A
Season in Hell*, Hanover Gallery, 1950.

Painter of compositions of male nudes,
semi-abstract, teacher Slade School.
Retrospective exhibition, Geffrye
Museum, May–June 1981.

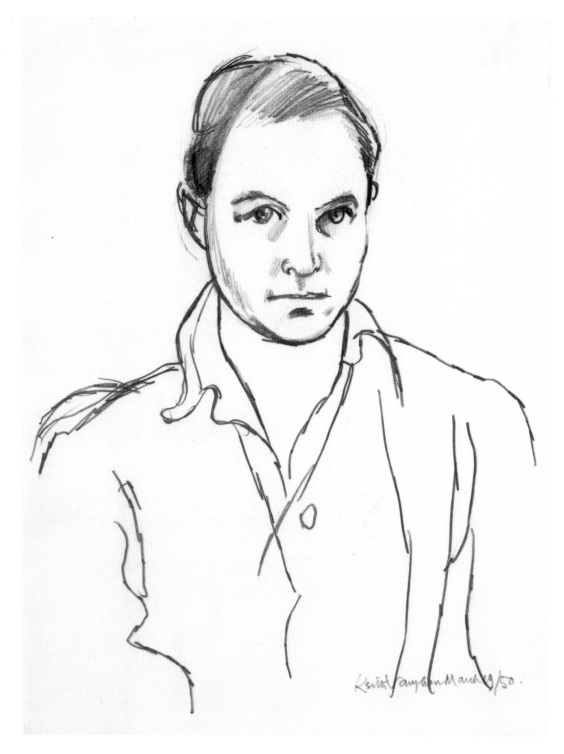

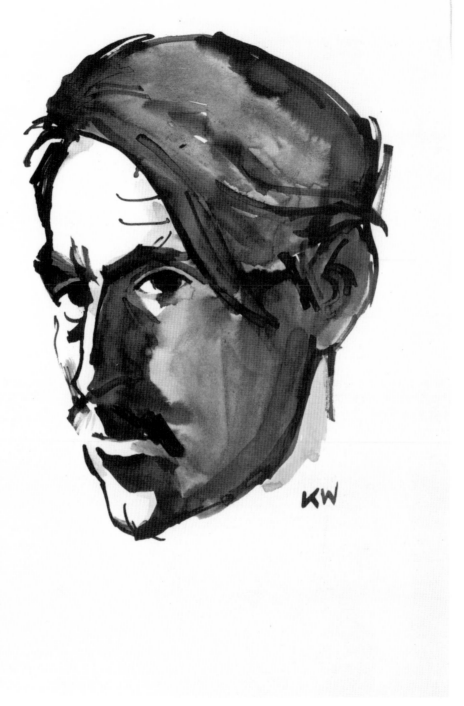

Kyffin Williams b.1913

Self-Portrait [1956] 8214.113

Ink and watercolour on paper
292 × 216 (11½ × 8½)
Inscribed 'K.W.' b.r.
AN & R, 4 February 1956, vol.8, no.1,
text by Mervyn Levy

Exhibition, 'Paintings', Prospect
Gallery, February 1956.

Landscape and portrait painter in
North Wales. Retrospective exhibition,
National Museum of Wales, Cardiff,
March–May 1987.

Edward Wolfe 1897–1982

Self-Portrait 8214.114

Ink on card 140 × 92 (5½ × 3⅛)
Inscribed 'Wolfe' b.r.
AN & R, 16 May 1953, vol.5, no.8, text
by David Cleghorn Thomson

Exhibition, O'Hana Gallery, May 1953.

Figure, still life and landscape painter,
born in Johannesburg, lived in London
and South Africa, member of 7 & 5
Society 1926–33. Moved to London in
1946. Retrospective exhibition,
Fieldbourne Galleries, February–March
1979.

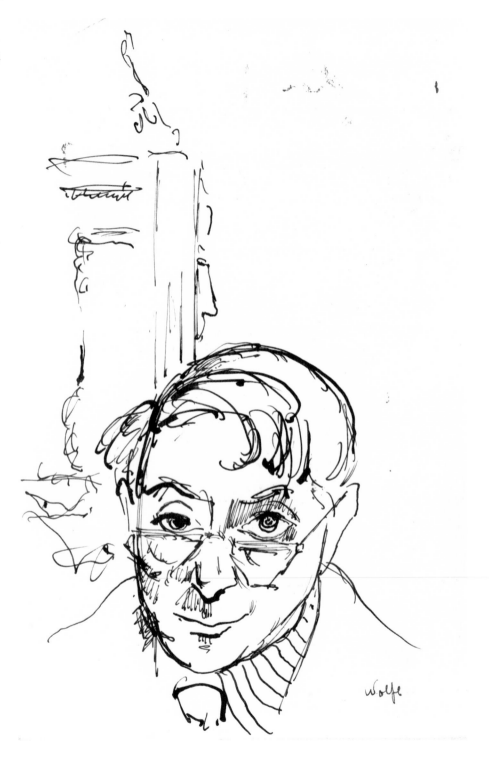

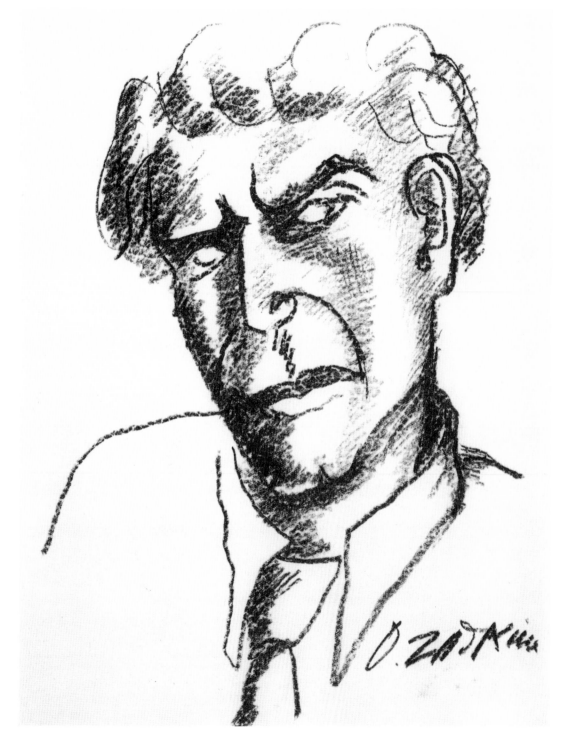

Ossip Zadkine 1890 – 1967

Self-Portrait 8214.115

Charcoal on paper 277 × 213
($10\frac{7}{8} \times 8\frac{3}{8}$)
Inscribed 'O. Zadkine' b.r.
AN & R, 15 July 1950, vol.2, no.12, text anon.

Exhibition and prizewinner, Venice Biennale, 1950.

Cubist sculptor, born in Russia, visited Britain in 1905, lived in Paris from 1909. Retrospective exhibition, Musée Rodin, Paris, 1972.

© ADAGP, Paris, DACS, London 1989.

Unidentified

Male Portrait 8214.116

Blue biro on grey paper 380 × 292
(15 × 11½)
Not inscribed
Not published

Unidentified

Male Portrait 8214.117

Ink on white paper 330×210
$(13 \times 8\frac{1}{4})$
Not inscribed
Not published

[115]

Unidentified

Female Portrait 8214.118

Blue ink wash on white paper
254 × 203 (10 × 8)
Not inscribed
Not published

Unidentified

Male Portrait 8214.119

Blue ink and pale blue gouache on
brown strawboard 267×172
$(10\frac{1}{2} \times 6\frac{3}{4})$
Not inscribed
Not published

Unidentified

Male Portrait 8214.120

Blue biro and pencil on white paper
181×181 ($7\frac{1}{8} \times 7\frac{1}{8}$)
Not inscribed
Not published

Unidentified

Male seated figure 8214.121
in hat

Charcoal on white paper 146 × 232
($5\frac{3}{4} × 9\frac{1}{8}$)
Not inscribed
Not published

Unidentified

Male profile silhouette 8214.122

Black and grey gouache and pencil on
white paper 197 × 162 (7⅜ × 6⅜)
Inscribed monogram b.r.
Not published

Loans and works from the Modern Collection

A number of significant works published by *Art News & Review* are not in the Archive Collection and as these works would enrich the display an attempt was made to trace those which appeared in the 'Portrait of the Artist' series, on the front page and during the life of the artist or sitter. We have therefore been able to include twelve works on loan and two works in the Tate Gallery Modern Collection.

The layout here follows the format used for the previous section except that entries for these loaned works include an indication of the lender and the Modern Collection works will have their own accession number.

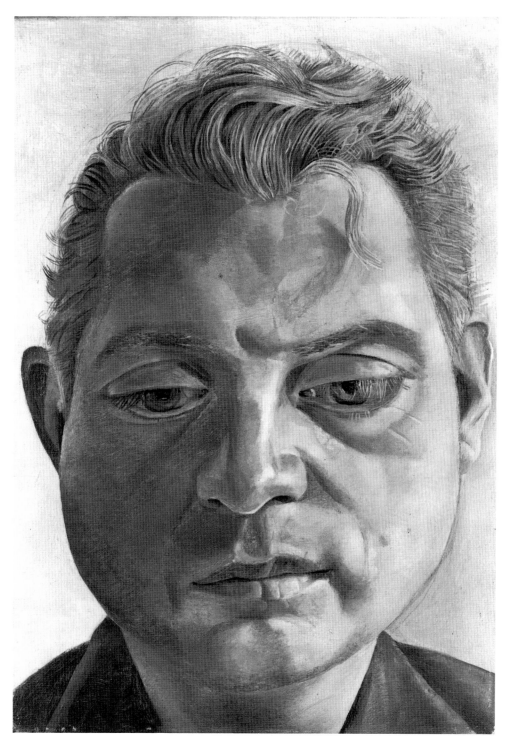

Francis Bacon b.1909

Portrait 1952
by Lucian Freud b.1922

Oil on copper plate 193 × 127 (7 × 5)
Not inscribed
AN & R, 29 May 1954, vol.6, no.9, text
anon.
Tate Gallery (N 06040)

Exhibition, Hanover Gallery, June-July
1954.

Figure painter, born Dublin, son of
race-horse trainer, brought up between
Ireland and England, visited Berlin and
Paris 1927–8, lives in London has lived
in Tangier and Paris. Retrospective
exhibitions, Tate Gallery, May–July
1962 and May–August 1985 and
foreign tour.

John Bratby b.1928

Self-Portrait [1954]

Oil on board 1220 × 726 (48 × 28½)
Not inscribed
AN & R, 1 October 1955, vol.8, no.18,
text anon.
Private Collection

Exhibition, Beaux Arts Gallery,
September–October 1955.

Painter of people, their artifacts and
environment, studied Royal College of
Art 1951–54, exhibited Venice
Biennale winning Guggenheim Award
1956, member of the 'Kitchen Sink
School'. Regular exhibitions including
portrait exhibition National Theatre
1978.

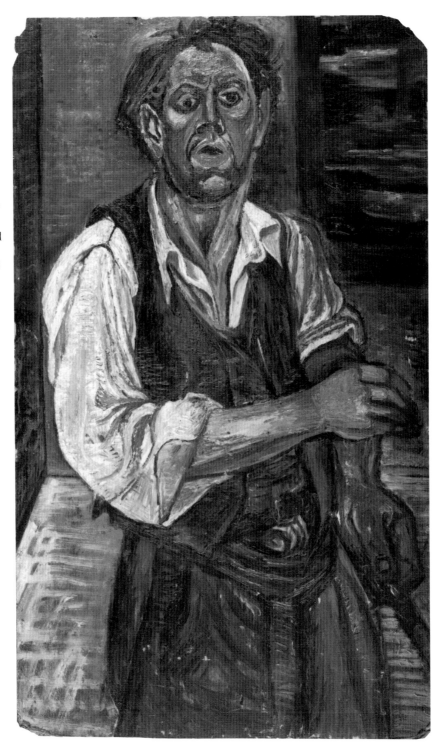

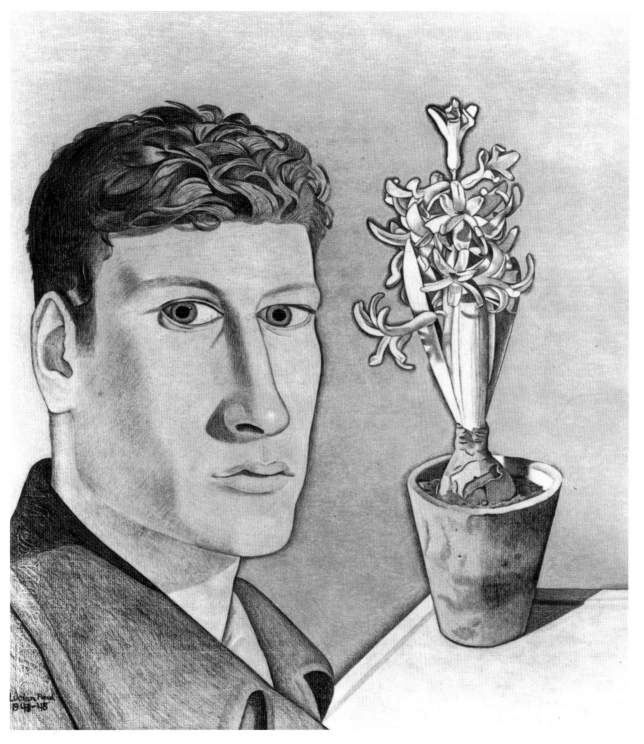

Lucian Freud b.1922

Self-Portrait with Hyacinth in Pot
1947–48

Pencil and coloured crayon on paper
445 × 413 (17½ × 16¼)
Signed and dated b.l.
AN & R, 17 June 1950, vol.11, no.10,
text by David Sylvester
Private Collection

Exhibition with Roger Vieillard,
Hanover Gallery, 1950.

Painter of people in interiors, born
Berlin, came to Britain 1933, studied
Central School of Arts & Crafts and East
Anglian School of Painting and
Drawing 1938–42. Lives in London.
Retrospective exhibition 1987–88,
Hirschhorn Museum, Washington;
Musée National d'Art Moderne, Paris;
South Bank Centre, London; Neue
Nationalgalerie, Berlin.

Derrick Greaves b.1927

Self-Portrait 1955

Pencil on paper 343 × 216 (13½ × 8½)
Not inscribed
AN & R, 10 November 1956, vol.8,
no.21, text by Pierre Rouve
Private Collection

Exhibition, Venice Biennale, 1956.

Painter of figures and landscapes, born
Sheffield, studied Royal College of Art
1948–52, exhibited Venice Biennale
1956 with Bratby, Smith and
Middleditch, the 'Kitchen Sink School'.
Decade exhibitions, Whitechapel 1973,
Graves Art Gallery, Sheffield 1980,
Loughborough College of Art and
Drawing 1986.

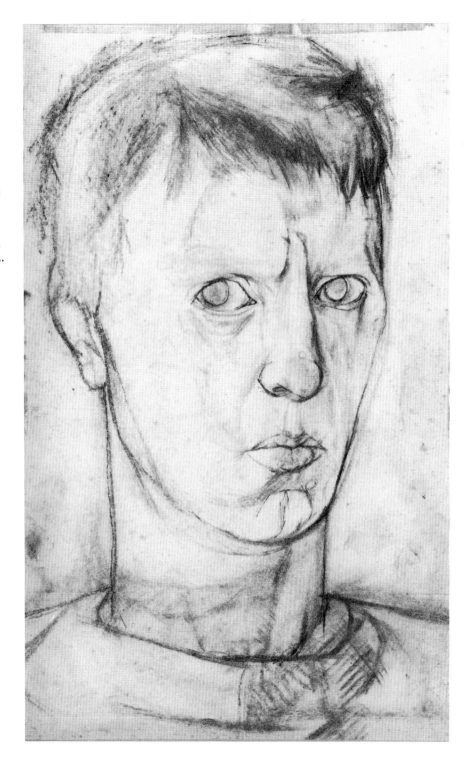

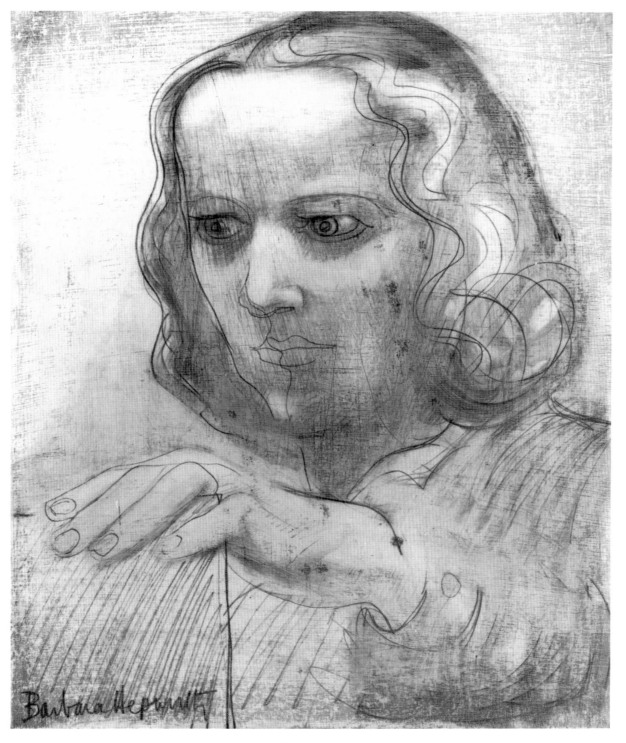

Barbara Hepworth

Dame Barbara Hepworth

1903–1975

Self-Portrait 1950

Oil and pencil on board 305 × 266
(12 × 10½)
Signed b.l.
AN & R, 11 February 1950, vol.2, no.1,
text by J.P. Hodin
National Portrait Gallery, London

Exhibition, Venice Biennale, 1950.

Sculptor in wood, stone and bronze
mainly abstract, born Yorkshire,
studied Leeds College of Art and Royal
College of Art 1919–1923. Lived
London and St Ives. Retrospective
exhibition, Tate Gallery April–May
1968.

Josef Herman b.1911

Self-Portrait 1946

Oil on canvas 483 × 420 (19 × 16½)
Signed and dated on verso
AN & R, 3 October 1953, vol.5, no.18,
text anon.
Josef Herman

Exhibition tour, Leicester Museum &
Art Gallery, York City Art Gallery,
Ferens Art Gallery, Hull, 1953.

Born Warsaw, painter of people in
context, studied Warsaw School of Art
and Decoration, organised group 'The
Phrygian Bonnet' 1935–36, came to
Britain via Belgium and France 1940.
Lived in Glasgow, South Wales, London
and Suffolk. Retrospective exhibition,
Camden Arts Centre, London
February–March 1980.

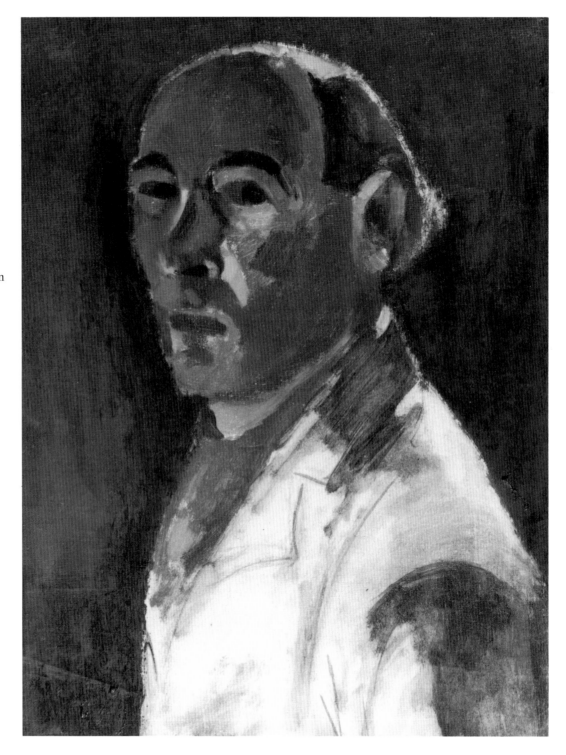

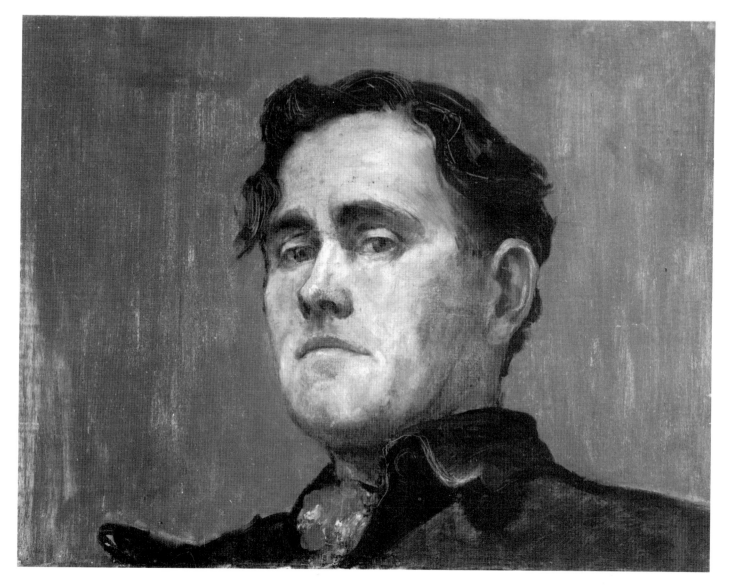

Derek Hill b.1916

Self-Portrait 1951–52

Oil on canvas 305 × 406 (12 × 16)
Not inscribed
AN & R, 28 September 1957, vol.9,
no.18, text by Mary Sorrell
Derek Hill

Exhibition, Leicester Galleries, 1957.

Painter of portraits and landscapes,
designer of opera and ballet sets and
writer on Islamic architecture. Born
Southampton, studied Munich, Paris,
Vienna and Russia, from 1936
travelled worldwide. Art Director
British School at Rome 1953–59. Lives
Donegal, London and Dorset.
Retrospective exhibition, Ulster
Museum, Belfast and Municipal
Museum of Modern Art, Dublin
1970–71.

Mary Kessell 1914–1977

Portrait [1957]
by Derek Hill b.1916

Pencil on paper 406 × 356 (16 × 14)
Signed b.r.
AN & R, 2 February 1957, vol.9, no.1,
(published as a self-portrait), text by
Mary Sorrell
Derek Hill

Painter of figure subjects and
abstractions, mural decorator and
illustrator, born London, studied
Central School of Arts & Crafts 1937–
39, became a lecturer in jewellery
1952–56. Memorial exhibition,
Camden Arts Centre, August–
September 1980.

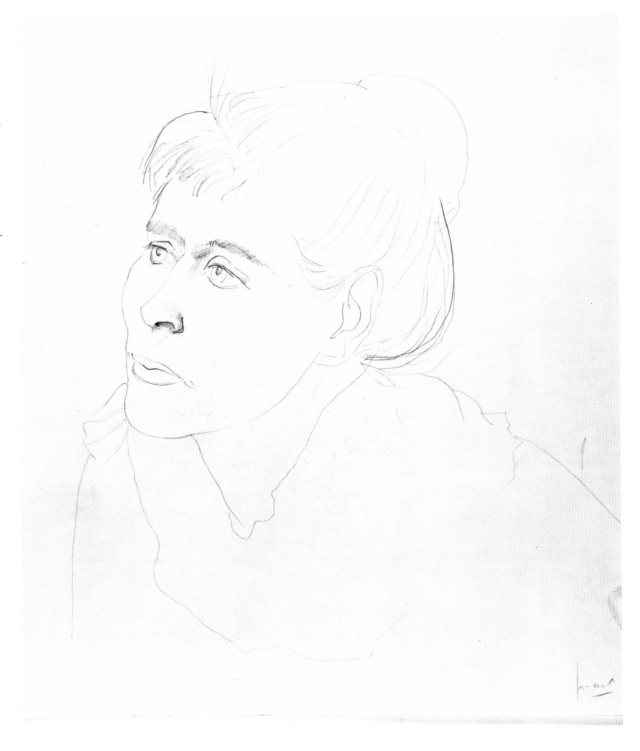

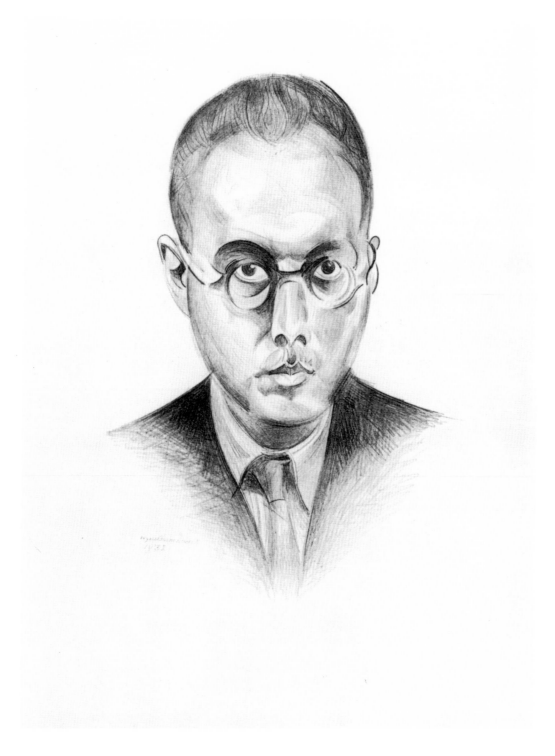

Wyndham Lewis 1882–1957

Self-Portrait 1932

Pencil on paper 331 × 255 (13 × 10)
Signed and dated
AN & R, 7 May 1949, vol. 1, no. 7, text
anon.
Private Collection

Retrospective exhibition Redfern
Gallery, May 1949.

Painter, etcher, author, born on his
father's yacht off the coast of Nova
Scotia, Canada. Studied Slade School,
1898–1901. Founder Vorticist Group
1914, editor 'Blast'. Retrospective
exhibition, Tate Gallery July–August
1956.

© Wyndham Lewis and the estate of
Mrs G.A. Lewis by permission of the
Wyndham Lewis Memorial Trust (A
Registered Charity).

Robert Medley b.1905

Self-Portrait c.1955

Oil on canvas 610 × 458 (24 × 18)
Signed
AN & R, 9 July 1955, vol.7, no.12, text
by Andrew Forge
Robert Medley

Exhibition Leicester Galleries, 1955.

Painter figurative and abstract subjects,
theatre designer, teacher and author,
born London, studied Slade School,
Academie Moderne, Paris, taught
Chelsea School of Art, Slade School,
Camberwell School of Art, Chairman
Faculty of Painting at the British School
at Rome, 1967–77. Retrospective
exhibition, Museum of Modern Art,
Oxford, April–May 1984–85 and tour.

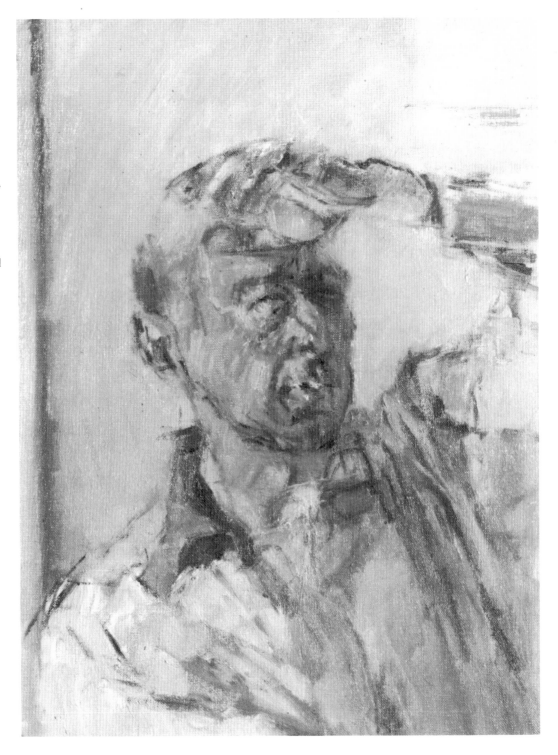

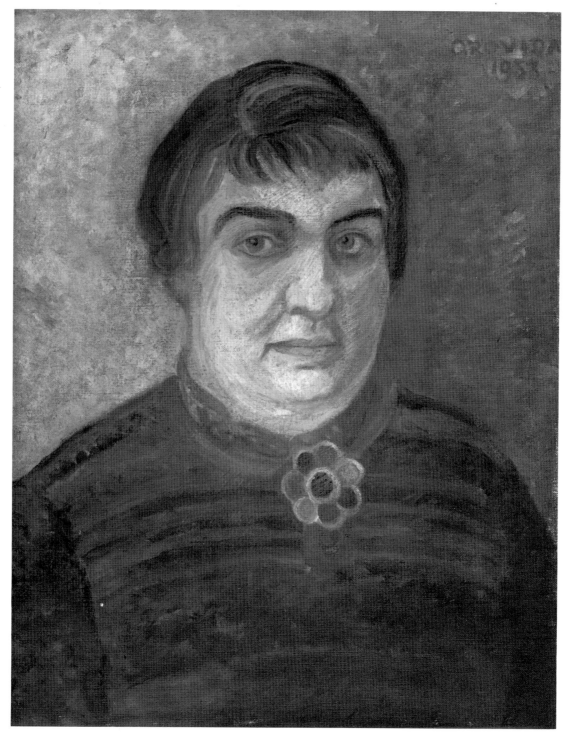

Orovida Pissarro 1893–1968

Self-Portrait 1953

Oil on canvas 509 × 407 (20 × 16)
Signed and dated t.r.
AN & R, 12 October 1957, vol.9, no.19,
text by C.W.
*Visitors of the Ashmolean Museum,
Oxford*

Exhibition, 'Orovida', O'Hana Gallery,
October 1957.

Painter of people and animals, print-
maker, born Essex, daughter of Lucien
and Esther Pissarro, art education with
family. Memorial exhibition,
Ashmolean Museum, Oxford, February
1969.

Matthew Smith 1879–1959

Portrait 1944
by Augustus John 1878–1961

Oil on canvas 610 × 508 (24 × 20)
Inscribed 'John' t.r.
AN & R, 10 September 1949, vol.1,
no.16, text by Mary Sorrell
Tate Gallery (N 05929)

Painter of nude, portrait, still-life and
landscape subjects. Born Halifax,
studied Manchester School of
Technology and Slade School. Lived
between France and England.
Retrospective exhibition Tate Gallery,
September–October 1953, Memorial
exhibition Royal Academy, October
1960.

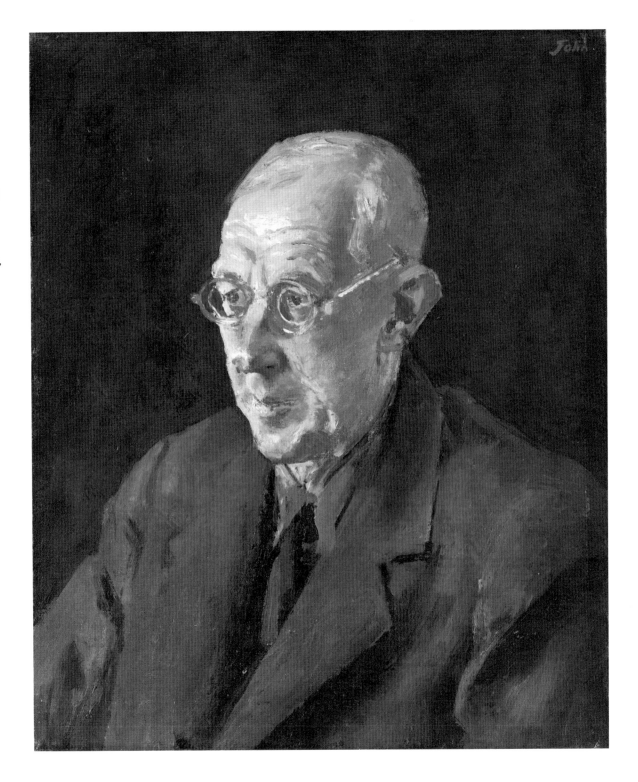

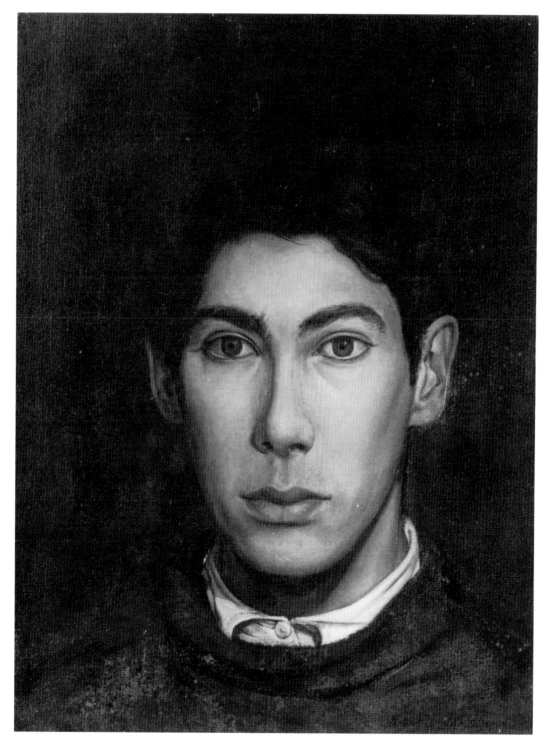

David Tindle b.1932

Self-Portrait 1955–56

Oil on canvas 380 × 280 (15 × 11)
Not inscribed
AN & R, 31 March 1956, vol.8, no.5,
text by Nigel Foxell
Private Collection

Exhibition Piccadilly Gallery, 1956.

Painter of figure, landscape and still-life
subjects, born Huddersfield, lives
Leamington Spa. Visiting tutor Royal
College of Art, 1972–83, elected Fellow
in 1981. Retrospective exhibition,
Central Art Gallery, Northampton
June–July 1972.

Edward Wadsworth

1889–1949

Self-Portrait [1932]

Egg tempera on gesso panel 311 × 228
($12\frac{1}{4} × 9$)
Not inscribed
AN & R, 12 March 1949, vol. 1, no. 3,
text anon.
Private Collection

Painter in tempera in both abstract and
figurative styles, especially of nautical,
landscape and still-life subjects. Born
Yorkshire, studied Slade School 1908–
12. Founder Member London Group
1913. Memorial exhibition Tate
Gallery, February–March 1951.

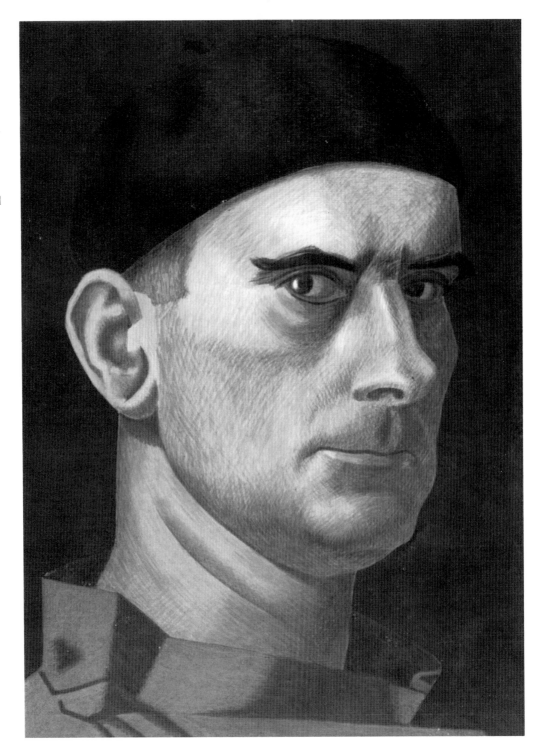

List of Portraits and Self-Portraits published in 'Art News & Review', from 1949

The names as listed are of the sitters, from time to time it is indicated that the portrait is by an artist other than the sitter. The names in capital letters indicate those published works which are now in the Tate Gallery Archive Collection 8214.1–122. Authors of accompanying texts in the journal have been indicated where they are known, but many of the texts are anonymous.

Starred items are loans to the Tate Gallery for the duration of the exhibition, 31 January–16 April 1989. A Tate Gallery number is printed beside the three items that were published by *Art News & Review* and are in the Tate Gallery's Modern and British Collections.

List of Portraits and Self-Portraits published in 'Art News & Review' from 1949

Sitter	Vol./No.	Date	Author
BERNARD MENINSKY, self-portrait	vol.1, no.1	12 February 1949	
GERTRUDE HERMES, self-portrait, 1949	vol.1, no.2	26 February 1949	D.W.
*Edward Wadsworth, self-portrait, 1937	vol.1, no.3	12 March 1949	
Henry Moore, by Feliks Topolski	vol.1, no.4	26 March 1949	
JOHN MINTON, self-portrait, 1949	vol.1, no.5	9 April 1949	
Peter Paul Rubens, self-portrait	vol.1, no.6	23 April 1949	Maurice Collis
*Wyndham Lewis, self-portrait, 1932	vol.1, no.7	7 May 1949	
Giorgio de Chirico, self-portrait	vol.1, no.8	21 May 1949	Maurice Collis
Michael Ayrton, self-portrait, 1948	vol.1, no.9	4 June 1949	
Massimo Campigli, self-portrait, 1946	vol.1, no.10	18 June 1949	Pierre Rouve
R.O. Dunlop, self-portrait	vol.1, no.11	2 July 1949	
S. John Woods, by John Minton, 1949	vol.1, no.12	16 July 1949	John Piper
Paul Gauguin, self-portrait	vol.1, no.13	30 July 1949	
FRED UHLMAN, by Morris Kestelman, 1949	vol.1, no.14	13 August 1949	Michael Rothenstein
Alan Ramsay, self-portrait	vol.1, no.15	27 August 1949	
Matthew Smith, by Augustus John, 1944 Tate Gallery N 05929	vol.1, no.16	10 September 1949	Mary Sorrell
Henry K. Gotlib, self-portrait	vol.1, no.17	24 September 1949	
Adrian Ryan, self-portrait	vol.1, no.18	8 October 1949	Eardley Knollys
Jack B. Yeats, by Feliks Topolski	vol.1, no.19	22 October 1949	Jack White
WILLIAM ROBERTS, self-portrait, 1949	vol.1, no.20	5 November 1949	William Roberts
Leonard Rosoman, self-portrait, 1949	vol.1, no.21	19 November 1949	
CECIL COLLINS, self-portrait, 1949	vol.1, no.22	3 December 1949	Bryan Robertson
KARIN JONZEN, self-portrait, 1949	vol.1, no.23	17 December 1949	Karin Jonzen
ROWLAND SUDDABY, self-portrait	vol.1, no.24	31 December 1949	
Francis Rose, by Christian Berard, 1929	vol.1, no.25	14 January 1950	Bryan Robertson
Joan Miro, by Louis Marcoussis	vol.1, no.26	28 January 1950	
*Dame Barbara Hepworth, self-portrait, 1950	vol.2, no.1	11 February 1950	J.P. Hodin
Fernand Léger, self-portrait	vol.2, no.2	25 February 1950	David Sylvester
Sir Jacob Epstein, by Augustus John	vol.2, no.3	11 March 1950	Mary Sorrell
Marie Laurençin, self-portrait	vol.2, no.4	25 March 1950	
KEITH VAUGHAN, self-portrait, 1950	vol.2, no.5	8 April 1950	
Eric Fraser, self-portrait, 1949	vol.2, no.6	22 April 1950	R.P. Gossop
Rodrigo Moynihan, self-portrait	vol.2, no.7	6 May 1950	
Stanley Spencer, self-portrait	vol.2, no.8	20 May 1950	Elizabeth Rothenstein
RONALD SEARLE, self-portrait	vol.2, no.9	3 June 1950	
*Lucian Freud, self-portrait, 1947–48	vol.2, no.10	17 June 1950	David Sylvester
Augustus John, self-portrait	vol.2, no.11	1 July 1950	
OSSIP ZADKINE, self-portrait	vol.2, no.12	15 July 1950	

Sitter	Vol./No.	Date	Author
CERI RICHARDS, self-portrait, 1950	vol.2, no.13	29 July 1950	Mary Sorrell
EDWARD BAWDEN, by Michael Rothenstein	vol.2, no.14	12 August 1950	D.P. Gossop
HANS TISDALL, self-portrait	vol.2, no.15	26 August 1950	
Eileen Agar, self-portrait	vol.2, no.16	12 September 1950	
JOHN O'CONNOR, self-portrait	vol.2, no.17	23 September 1950	
Clifford Hall, self-portrait, 1950	vol.2, no.18	7 October 1950	
WILLIAM TOWNSEND, self-portrait	vol.2, no.19	21 October 1950	
IVON HITCHENS, self-portrait	vol.2, no.20	4 November 1950	Mary Sorrell
JAMES BOSWELL, self-portrait, 1950	vol.2, no.21	18 November 1950	
Robert Buhler, self-portrait	vol.2, no.22	2 December 1950	
Robert Gibbings, by Marshall Hutson	vol.2, no.23	16 December 1950	
Alicia Boyle, self-portrait, 1950	vol.2, no.24	30 December 1950	
MICHAEL ROTHENSTEIN, self-portrait, 1950	vol.2, no.25	13 January 1951	Bryan Robertson
Joss, self-portrait	vol.2, no.26	27 January 1951	
WILLIAM SCOTT, self-portrait, 1950	vol.3, no.1	10 February 1951	
HANS FEIBUSCH, self-portrait	vol.3, no.2	24 February 1951	
JAN LE WITT, self-portrait	vol.3, no.3	10 March 1951	
ANTHONY LEVETT-PRINSEP, self-portrait, 1951	vol.3, no.4	24 March 1951	
MURIEL PEMBERTON, self-portrait	vol.3, no.5	7 April 1951	
FELIKS TOPOLSKI, by Janina Konarska, 1950	vol.3, no.6	21 April 1951	
JEAN HÉLION, self-portrait, 1951	vol.3, no.7	5 May 1951	A.D.B. Sylvester
Mauricio Lasansky, self-portrait	vol.3, no.8	19 May 1951	
LOUIS LE BROCQUY, self-portrait	vol.3, no.9	2 June 1951	
CLAUDE ROGERS, self-portrait	vol.3, no.10	16 June 1951	
Marc Chagall, self-portrait	vol.3, no.11	30 June 1951	
William Hogarth, self-portrait, Tate Gallery N 00112	vol.3, no.12	14 July 1951	
Antoni Clavé, self-portrait	vol.3, no.13	28 July 1951	
EILEEN MAYO, self-portrait 1951	vol.3, no.14	11 August 1951	
Anthony Underhill, self-portrait	vol.3, no.15	25 August 1951	
Henry Lamb, self-portrait	vol.3, no.16	8 September 1951	
Samuel Palmer, self-portrait	vol.3, no.17	22 September 1951	
LORD METHUEN, self-portrait 1951	vol.3, no.18	6 October 1951	Mary Sorrell
Pablo Picasso, self-portrait	vol.3, no.19	20 October 1951	
William Dobson, self-portrait	vol.3, no.20	3 November 1951	
Edvard Munch, self-portrait	vol.3, no.21	11 November 1951	
Henri Gaudier-Brzeska, self-portrait	vol.3, no.22	1 December 1951	
DOM ROBERT, self-portrait, 1951	vol.3, no.23	15 December 1951	
J.M.W. Turner, self-portrait	vol.3, no.24	29 December 1951	
JULIAN TREVELYAN, self-portrait, 1951	vol.3, no.25	12 January 1952	
ZDZISLAW RUSKOWSKI, self-portrait	vol.3, no.26	26 January 1952	
Alfred Wolmark, self-portrait	vol.4, no.1	9 February 1952	
MERLYN EVANS, self-portrait, 1952	vol.4, no.2	23 February 1952	
Leonardo da Vinci, self-portrait	vol.4, no.3	8 March 1952	

Sitter	Vol./No.	Date	Author
ANNE REDPATH, self-portrait	vol.4, no.4	22 March 1952	Mary Sorrell
Nicholas Egon, self-portrait	vol.4, no.5	5 April 1952	
Lord Leighton, by G.F. Watts	vol.4, no.6	19 April 1952	
Patrick Heron, self-portrait	vol.4, no.7	3 May 1952	David Sylvester
Daniel O'Neill, self-portrait, 1952	vol.4, no.8	17 May 1952	Maurice Collis
Gwen John, self-portrait	vol.4, no.9	31 May 1952	
Eugène Delacroix, self-portrait	vol.4, no.10	14 June 1952	
EDWARD ARDIZZONE, self-portrait, 1952	vol.4, no.11	28 June 1952	
Denis Peploe, self-portrait	vol.4, no.12	12 July 1952	C.W.
Charles Keene, self-portrait	vol.4, no.13	26 July 1952	
Chien-Ying Chang, by Stanley Spencer	vol.4, no.14	9 August 1952	Mary Sorrell
D.G. Rossetti, by Charles Keene	vol.4, no.15	23 August 1952	
Oskar Kokoschka, self-portrait	vol.4, no.16	6 September 1952	J.P. Hodin
Edgar Degas, self-portrait	vol.4, no.17	20 September 1952	
Jean Géricault, self-portrait	vol.4, no.18	4 October 1952	Neville Wallis
Colin Middleton, self-portrait, 1952	vol.4, no.19	18 October 1952	Sheila Greene
Sir Frank Brangwyn, self-portrait	vol.4, no.20	1 November 1952	
John Piper, self-portrait	vol.4, no.21	15 November 1952	S. John Woods
Henri Matisse, self-portrait	vol.4, no.22	29 November 1952	
PAUL HOGARTH, self-portrait, 1952	vol.4, no.23	13 December 1952	John Berger
James Thurber, self-portrait	vol.4, no.24	27 December 1952	
Max Chapman, self-portrait, 1952	vol.4, no.25	10 January 1953	Derek Rogers
Pierre-Auguste Renoir, self-portrait	vol.4, no.26	24 January 1953	
CHENG-WU FEI, self-portrait, 1953	vol.5, no.1	7 February 1953	Mary Sorrell
PETER FOLDES, self-portrait, 1953	vol.5, no.2	21 February 1953	Ronald Alley
WILLIAM JOHNSTONE, by Morris Kestelman 1953	vol.5, no.3	7 March 1953	Max Bernd-Cohen
Frida Kahlo, self-portrait, 1943	vol.5, no.4	21 March 1953	Susana Gamboa
Edmund X. Kapp	vol.5, no.5	4 April 1953	Bryan Robertson
WILLIAM GEAR, self-portrait, 1953	vol.5, no.6	18 April 1953	Crieff Williamson
Le Corbusier, self-portrait	vol.5, no.7	2 May 1953	
EDWARD WOLFE, self-portrait	vol.5, no.8	16 May 1953	David Cleghorn-Thomson
PIERO SANSALVADORE, self-portrait, 1953	vol.5, no.9	30 May 1953	Pierre Rouve
Thomas Gainsborough, self-portrait	vol.5, no.10	13 June 1953	
André Derain, self-portrait	vol.5, no.11	27 June 1953	
Thomas Rowlandson, self-portrait	vol.5, no.12	11 July 1953	
PIETRO ANNIGONI, self-portrait, 1953	vol.5, no.13	25 July 1953	Mary Sorrell
Georges Rouault, self-portrait	vol.5, no.14	8 August 1953	
Sir W.G. GILLIES, self-portrait	vol.5, no.15	22 August 1953	David Cleghorn-Thomson
Sir EDUARDO PAOLOZZI, self-portrait	vol.5, no.16	5 September 1953	Toni del Renzio
ITHELL COLQUHOUN, self-portrait	vol.5, no.17	19 September 1953	
*Josef Herman, self-portrait	vol.5, no.18	3 October 1953	
John Martin, by Charles Martin	vol.5, no.19	17 October 1953	
André de Lanskoy, self-portrait	vol.5, no.20	31 October 1953	
René Magritte, self-portrait	vol.5, no.21	14 November 1953	Lawrence Alloway
BRIAN ROBB, self-portrait	vol.5, no.22	28 November 1953	H.S. Williamson

Sitter	Vol./No.	Date	Author
Anthony van Dyck, self-portrait	vol.5, no.23	12 December 1953	Augustus John
Ambrose McEvoy, self-portrait	vol.5, no.24	26 December 1953	
Martin Bloch, self-portrait	vol.5, no.25	9 January 1954	Josef Herman
Justin Pieris Daraniyagala, self-portrait	vol.5, no.26	23 January 1954	Ranjit Fernando
A child, aged 11	vol.6, no.1	6 February 1954	
Paul Rebyrolle, self-portrait	vol.6, no.2	20 February 1954	Neville Wallis
Eleanor Whittell, by Chien-Ying Chang	vol.6, no.3	6 March 1954	Mary Sorrell
J. McNeill Whistler, self-portrait	vol.6, no.4	20 March 1954	
Adrian Hill, self-portrait	vol.6, no.5	3 April 1954	
Emilio Greco, self-portrait	vol.6, no.6	17 April 1954	
Winston Churchill, by Ambrose McEvoy	vol.6, no.7	1 May 1954	John Rothenstein
Edouard Manet, self-portrait	vol.6, no.8	15 May 1954	
Francis Bacon, by Lucian Freud, 1952, Tate Gallery N 06040	vol.6, no.9	29 May 1954	
Francisco de Goya, self-portrait	vol.6, no.10	12 June 1954	
BLAIR HUGHES-STANTON, self-portrait	vol.6, no.11	26 June 1954	
SIEGFRIED CHAROUX, self-portrait, 1953	vol.6, no.12	10 July 1954	Mary Sorrell
Ben Nicholson, self-portrait	vol.6, no.13	24 July 1954	J.P. Hodin
Fahr-el-Nissa Zeid, self-portrait	vol.6, no.14	7 August 1954	
George Catlin, self-portrait	vol.6, no.15	21 August 1954	
Paul Cézanne, self-portrait	vol.6, no.16	4 September 1954	
Albert Reuss, self-portrait	vol.6, no.17	18 September 1954	
NIGEL LAMBOURNE, self-portrait	vol.6, no.18	2 October 1954	
EDGARD TYTGAT, self-portrait	vol.6, no.19	16 October 1954	
FRITZ KRAMER, self-portrait	vol.6, no.20	30 October 1954	
FRANCES RICHARDS, self-portrait, [1954]	vol.6, no.21	13 November 1954	
Robert Colquhoun, self-portrait, 1954	vol.6, no.22	27 November 1954	Bryan Robertson
Thomas Lawrence, self-portrait	vol.6, no.23	11 December 1954	Lawrence Alloway
David Jones, self-portrait	vol.6, no.24	25 December 1954	
Peter Lely, self-portrait	vol.6, no.25	8 January 1955	
DAVID MICHIE, self-portrait	vol.6, no.26	22 January 1955	David Cleghorn-Thomson
Nikolas H. Ghika, self-portrait	vol.7, no.1	5 February 1955	Dora Vallier
Eric Young, self-portrait, 1955	vol.7, no.2	19 February 1955	
MICHEL KIKOINE, self-portrait	vol.7, no.3	15 March 1955	Georges Pillement
Archibald Ziegler, self-portrait, 1954	vol.7, no.4	19 March 1955	F. Joss
RENATO GUTTUSO, self-portrait, 1955	vol.7, no.5	2 April 1955	Pierre Rouve
André Masson, self-portrait, 1955	vol.7, no.6	16 April 1955	
Constance Bolton, self-portrait, 1955	vol.7, no.7	30 April 1955	Alan Brownjohn
Sir Sidney Nolan, self-portrait, 1955	vol.7, no.8	14 May 1955	
MERVYN LEVY, self-portrait	vol.7, no.9	28 May 1955	
Henri de Saint Delis, self-portrait	vol.7, no.10	11 June 1955	Terence Mullaly
Alberto Giacometti, self-portrait	vol.7, no.11	25 June 1955	
*Robert Medley, self-portrait	vol.7, no.12	9 July 1955	Andrew Forge
Angelica Kauffmann, self-portrait	vol.7, no.13	23 July 1955	

Sitter	Vol./No.	Date	Author
Piet Mondrian, self-portrait	vol.7, no.14	6 August 1955	Andrew Forge
Carel Weight, self-portrait, 1938	vol.7, no.15	20 August 1955	
Tseng Yu, self-portrait, 1955	vol.7, no.16	3 September 1955	William Townsend
DONALD HAMILTON FRASER, self-portrait, 1955	vol.7, no.17	17 September 1955	
*John Bratby, self-portrait	vol.7, no.18	1 October 1955	
François Marchand, self-portrait	vol.7, no.19	15 October 1955	
Nuno Goncales, self-portrait	vol.7, no.20	29 October 1955	
KATHLEEN ALLEN, self-portrait, 1955	vol.7, no.21	12 November 1955	
EDWIN LA DELL, self-portrait, 1955	vol.7, no.22	26 November 1955	
ALFRED HARRIS, self-portrait, 1955	vol.7, no.23	10 December 1955	
Charles Higgins (Pic), by Kate Oliver	vol.7, no.24	24 December 1955	Pic
John Flaxman, self-portrait	vol.7, no.25	7 January 1956	
Ben Shahn, self-portrait, 1955	vol.7, no.26	21 January 1956	
KYFFIN WILLIAMS, self-portrait, 1956	vol.8, no.1	4 February 1956	Mervyn Levy
F.E. McWILLIAM, self-portrait, 1956	vol.8, no.2	18 February 1956	Albert Garrett
ALAN REYNOLDS, by Francis Sisley, 1956	vol.8, no.3	3 March 1956	K.G. Sutton
Stefan Knapp, self-portrait, 1956	vol.8, no.4	17 March 1956	Pierre Rouve
*David Tindle, self-portrait	vol.8, no.5	31 March 1956	Nigel Foxell
DOLF RIESER, self-portrait	vol.8, no.6	14 April 1956	G.E. Speck
Richard Chopping, self-portrait	vol.8, no.7	28 April 1956	Mary Sorrell
Ghiglion-Green, self-portrait	vol.8, no.8	12 May 1956	Terence Mullaly
Rembrandt, self-portrait	vol.8, no.9	26 May 1956	Nigel Foxell
John Marshall, self-portrait	vol.8, no.10	9 June 1956	Mary Sorrell
Paul Klee, self-portrait	vol.8, no.11	23 June 1956	
Suzanne Valadon, self-portrait	vol.8, no.12	7 July 1956	
Paul Girol, self-portrait	vol.8, no.13	21 July 1956	
WALTER BATTISS, self-portrait	vol.8, no.14	4 August 1956	
COLIN MOSS, self-portrait	vol.8, no.15	18 August 1956	Mervyn Levy
J.F. Millet, daguerrotype	vol.8, no.16	1 September 1956	Eric Newton
Ralph Wardle, self-portrait	vol.8, no.17	15 September 1956	R.G.
Marek Zalawski, self-portrait, 1956	vol.8, no.18	29 September 1956	
Richard Butler, self-portrait, 1956	vol.8, no.19	13 October 1956	
FREDERICK SCHAEFFER, self-portrait	vol.8, no.20	27 October 1956	Mary Sorrell
*Derrick Greaves, self-portrait	vol.8, no.21	10 November 1956	Pierre Rouve
Leopold Pascal, self-portrait	vol.8, no.22	24 November 1956	Anthony Rye
Llwellyn Petley-Jones, self-portrait, 1956	vol.8, no.23	8 December 1956	Anthony Rye
Giorgio Morandi, self-portrait	vol.8, no.24	22 December 1956	Pierre Rouve
Moise Kisling, by A. Modigliani	vol.8, no.25	5 January 1957	John Jeffcott
PHILIP SUTTON, self-portrait	vol.8, no.26	19 January 1957	K.S.
*Mary Kessell, by Derek Hill	vol.9, no.1	2 February 1957	Mary Sorrell
Vincent van Gogh, self-portrait, 1889	vol.9, no.2	16 February 1957	Mervyn Levy
ALFRED DANIELS, self-portrait, 1957	vol.9, no.3	2 March 1957	Charles S. Spencer
Enrico Baj, self-portrait, 1954	vol.9, no.4	16 March 1957	
John Armstrong, by Gertrude Hermes, 1957	vol.9, no.5	30 March 1957	Mary Sorrell
T. Copplestone, self-portrait, 1957	vol.9, no.6	13 April 1957	
MILEIN COSMAN, self-portrait, 1957	vol.9, no.7	27 April 1957	
JOHN NAPPER, self-portrait, 1957	vol.9, no.8	11 May 1957	L.M.
Reuben Rubin, self-portrait, 1957	vol.9, no.9	25 May 1957	R.G.
Maurice de Vlaminck, self-portrait, 1957	vol.9, no.10	8 June 1957	James Burr
RALPH RUMNEY, self-portrait, 1957	vol.9, no.11	22 June 1957	R.C.
JACK SIMCOCK, self-portrait, 1957	vol.9, no.12	6 July 1957	Reginald Haggar
John Coplans, photograph	vol.9, no.13	20 July 1957	
Raoul Dufy, self-portrait	vol.9, no.14	3 August 1957	R.G.
DAVID PARTRIDGE, self-portrait, 1957	vol.9, no.15	17 August 1957	R.G.
Stephen Andrews, self-portrait, 1957	vol.9, no.16	31 August 1957	
Guido Pajetta, self-portrait, 1957	vol.9, no.17	14 September 1957	
*Derek Hill, self-portrait	vol.9, no.18	28 September 1957	Mary Sorrell
*Orovida Pissarro, self-portrait	vol.9, no.19	12 October 1957	C.W.
Don Fink, photograph	vol.9, no.20	26 October 1957	G.M. Butcher
LOUIS JAMES, self-portrait	vol.9, no.21	9 November 1957	Pierre Rouve
Martin Bradley, self-portrait	vol.9, no.22	23 November 1957	G.M. Butcher
Francis Newton Souza, self-portrait	vol.9, no.23	7 December 1957	G.M. Butcher
Mary Filer, self-portrait	vol.9, no.24	21 December 1957	C.A. Burland
DAVID PERETZ, self-portrait	vol.9, no.25	4 January 1958	Pierre Rouve
Michael Andrews, by Keith Sutton	vol.9, no.26	18 January 1958	Keith Sutton
Robert Delaunay, self-portrait, 1909	vol.10, no.1	1 February 1958	Pierre Rouve
Juan Gris, self-portrait	vol.10, no.2	15 February 1958	Pierre Rouve
Dame Elizabeth Frink, self-portrait, 1958	vol.10, no.3	1 March 1958	Mervyn Levy
Jack Clemente, self-portrait, 1949	vol.10, no.4	15 March 1958	
Richard Beer, self-portrait	vol.10, no.5	29 March 1958	James Burr
Marcel Cardinal, self-portrait	vol.10, no.6	12 April 1958	
Chatin Sarachi, self-portrait, 1957	vol.10, no.7	26 April 1958	J.P. Hodin
Bill Newcombe, self-portrait, 1958	vol.10, no.8	10 May 1958	Jasia Reichardt
MORLEY BURY, self-portrait	vol.10, no.9	24 May 1958	Michael Chase
Léon Zack, self-portrait	vol.10, no.10	7 June 1958	Jasia Reichardt
Denis Bowen, self-portrait	vol.10, no.11	21 June 1958	John Coplans
Albert Marquet, self-portrait	vol.10, no.12	5 July 1958	
George Ehrlich, self-portrait, 1940	vol.10, no.13	19 July 1958	Mervyn Levy
Erich Kahn, self-portrait, 1958	vol.10, no.14	2 August 1958	J.P. Hodin
THÉODORE BRENSON, self-portrait	vol.10, no.15	16 August 1958	Reginald Devigne
Daryl Hill, self-portrait, 1958	vol.10, no.16	30 August 1958	Denis Bowen
HAROLD CHEESMAN, self-portrait	vol.10, no.17	13 September 1958	William Calvert
Victor Pasmore, photograph	vol.10, no.18	27 September 1958	Jasia Reichardt
Trevor Bell, photograph	vol.10, no.19	11 October 1958	James Burr
JOHN CHRISTOFOROU, self-portrait	vol.10, no.20	25 October 1958	John Coplans
No portrait	vol.10, no.21	8 November 1958	
John Lavrin, self-portrait	vol.10, no.22	22 November 1958	Mary Sorrell
Jankel Adler, self-portrait	vol.10, no.23	6 December 1958	Jasia Reichardt
Bruce Tippett, photograph	vol.10, no.24	20 December 1958	Alan Bowness
No portrait	vol.10, no.25	3 January 1959	
No portrait	vol.10, no.26	17 January 1959	
Gwen Barnard, self-portrait, 1959	vol.11, no.1	31 January 1959	Jasia Reichardt
Douglas Portway, photograph	vol.11, no.2	14 February 1959	
Leonie Jonleigh, self-portrait	vol.11, no.3	28 February 1959	
Guy Warren, photograph	vol.11, no.4	14 March 1959	Denis Bowen
PHOEBUS TUTTNAUER, self-portrait, 1959	vol.11, no.5	28 March 1959	Mervyn Levy

Sitter	Vol./No.	Date	Author	Sitter	Vol./No.	Date	Author
Henry Inlander, self-portrait, 1959	vol.11, no.6	11 April 1959	James Burr	Ettore Colla, photograph	vol.11, no.17	12 September 1959	Jasia Reichardt
Jean-Michel Atlan, photograph	vol.11, no.7	25 April 1959	Jasia Reichardt	No portrait	vol.11, no.18	26 September 1959	
Nina Tryggvadottir, self-portrait, 1959	vol.11, no.8	9 May 1959	J.P. Hodin	Paul Millichip, photograph	vol.11, no.19	10 October 1959	Philip Gibbon
				Else Meidner, self-portrait, 1958	vol.11, no.20	24 October 1959	J.P. Hodin
No portrait	vol.11, no.9	23 May 1959		George Melhuish, photograph	vol.11, no.21	7 November 1959	Jasia Reichardt
Francis Bott, photograph	vol.11, no.10	6 June 1959		David Alfaro Siqueiros, self-portrait	vol.11, no.22	21 November 1959	Alfred Werner
John Plumb, photograph	vol.11, no.11	20 June 1959	John Coplans	Joseph Lacasse, photograph	vol.11, no.23	5 December 1959	Pierre Rouve
No portrait	vol.11, no.12	4 July 1959		Maurice Collis, photograph	vol.11, no.24	19 December 1959	Jasia Reichardt
Kit Barker, self-portrait, 1959	vol.11, no.13	18 July 1959	Howard Griffin	Alistair Grant, photograph	vol.11, no.25	2 January 1960	Iain Forbes White
Celso Lagar, by Amedeo Modigliani, 1919	vol.11, no.14	1 August 1959	Andreas Kalman	No portrait	vol.11, no.26	16 January 1960	
				Marie-Louise Motesiczky, self-portrait 1943	vol.12, no.1	30 January 1960	J.P. Hodin
Aubrey Williams, photograph	vol.11, no.15	15 August 1959	Jan Carew				
MAURICE JADOT, by F.N. Souza, 1959	vol.11, no.16	29 August 1959	Denis Bowen	FELIKS TOPOLSKI, self-portrait	vol.20, no.3	17 February 1968	

Index

The Index refers to the *Introduction* and two *Catalogue* sections only, giving page references to all sitters and artists, page references for illustrations are in bold type.